W9-CPC-148

IMAGES
of America

CARROLL COUNTY

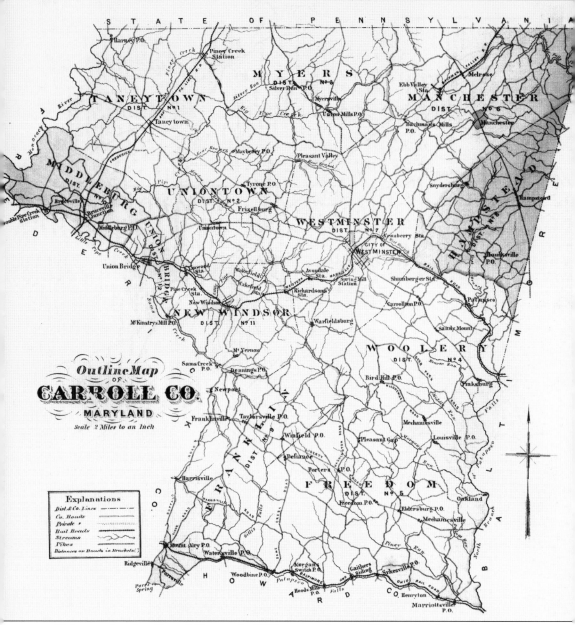

This map showing Carroll County in 1877 appeared in the *Illustrated Atlas of Carroll County*, published by Lake, Griffing, and Stevenson. According to the 1870 census, Carroll County's population was 28,619. The Westminster District was the largest, with Manchester District second. (HSCC.)

ON THE COVER: Carroll County sent this float as its representative in the parade celebrating the opening of the Severn River Bridge at Annapolis in 1923. (HSCC.)

IMAGES
of America

CARROLL COUNTY

Catherine Baty on behalf of
the Historical Society of Carroll County

ARCADIA
PUBLISHING

Copyright © 2006 by the Historical Society of Carroll County
ISBN 978-0-7385-4302-4

Published by Arcadia Publishing
Charleston SC, Chicago IL, Portsmouth NH, San Francisco CA

Printed in the United States of America

Library of Congress Catalog Card Number: 2006925382

For all general information contact Arcadia Publishing at:
Telephone 843-853-2070
Fax 843-853-0044
E-mail sales@arcadiapublishing.com
For customer service and orders:
Toll-Free 1-888-313-2665

Visit us on the Internet at www.arcadiapublishing.com

*To all those—past, present, and future—who love and preserve
Carroll County's history.*

CONTENTS

ACKNOWLEDGMENTS

One of the things that impressed me when I moved to Carroll County was how many of today's residents can trace their family back for generations in the county. In today's mobile society, that type of longevity is getting hard to find. Like many of its constituents, the Historical Society of Carroll County also has deep roots. The society was established in 1939 "to collect and preserve all papers, books, documents or other matter or things pertaining to the history of Carroll County." Since then, the society has acquired an amazing collection, including wonderful images of Carroll County. Thanks need to go to the staff and volunteers who have researched the photograph collection over the years, including Lillian Shipley, Joanne Manwaring, Joe Getty, Jay Graybeal, Gregory Goodell, Rebecca Fifield, Tyler Boone, Mary Ann Ashcraft, and many others. Each has contributed to the resources that were used in preparing the text of this book. Thanks also to those generous individuals who have donated photographs to the society over the years.

Many of the photographs in this volume are from collection of the Historical Society of Carroll County. For brevity, they have been identified "HSCC." Groups and individuals around the county have also contributed images for this book. Special thanks go to the Historical Society of Mount Airy (Mike Eacho), the Manchester Historical Center (Julia Berwager and Kathryn Riley), Angelo Monteleone, the New Windsor Heritage Committee (Bryce Workman), Bob Porterfield, the Sykesville Gate House Museum (Kari Greenwalt, director, and Jaime Bradley, curator), and the Union Bridge Heritage Committee (Joan McKee).

INTRODUCTION

The first land patent in the area that would become Carroll County was issued in 1723 to Benjamin Belt for a tract he named Belt's Hills. Belt was but the first of many to buy land in the county. Well-traveled trails used by the Susquehannock, Shawnee, and Delaware tribes crossed the region and became the roads followed by European settlers. Richard Owings laid out the first public road in 1737 through the northeastern section of the county. Settlers from north and east followed that road into the area around Manchester and Hampstead, while emigrants from Pennsylvania moved south into the northern and northwestern parts of the county. Other settlers moved north along the Patapsco River into the southern part of the region.

Since 1750, Baltimore and Frederick Counties were divided by a line that ran near the city of Westminster. By the early 19th century, support was growing for the idea of creating a new county along the border. Those living near the border found it difficult to travel to the county seats to conduct business. The court systems were overburdened, and establishing a new county with its own courts would alleviate those problems. As early as 1813, local newspapers called for creation of a new county to be called "Union County." After several failed attempts, the legislature passed "an act for the division of Baltimore and Frederick counties," and created a new one to be called "Carroll." The name was chosen to honor Charles Carroll of Carrollton, a signer of the Declaration of Independence who died in 1832. (Though Carroll owned land in the area, he never lived there.) The act took effect on January 19, 1837. Westminster, near the geographic center, was chosen as the seat of government for the county.

From its earliest days, the county was primarily agricultural. Rich land attracted farming families. Mills sprang up along the creeks and streams to process the produce. The arrival of the railroad and construction of turnpikes boosted the county's economy. Improved roads led to Baltimore, Frederick, Hanover, Washington, and other major markets. The Baltimore and Ohio, Western Maryland, and Frederick and Pennsylvania Line railroads spurred an economic boom in the first half of the 19th century.

Eight cities grew in Carroll County: Westminster (at the center), Hampstead, Manchester, Mount Airy, New Windsor, Sykesville, Taneytown, and Union Bridge (along the borders). The merchants, bankers, and tradesmen who set up shop in the cities provided essential services for farmers in the surrounding area. However, most residents lived on farms or in the small crossroad communities scattered around the county.

In the last half of the 19th century, industries grew that utilized local resources. Tanneries, paper mills, canneries, and quarries appeared and began to diversify the county's economy. In the 1890s, Carroll County farmers began growing wormseed. The oil from this plant was a curative for hookworm and ringworm in humans and animals. By the 1920s, Carroll County was the world's leading producer of wormseed, with county farms growing over 45,000 pounds annually and over 100 stills across the county distilling the oil. Manufacturing increased in the 20th century with the growth of heavy industrial manufacturing plants such as Baltimore Roofing Company, Congoleum, Blue Ridge Rubber Company, and Black and Decker. Today the mix of agriculture, manufacturing, service industries, and historic communities gives Carroll County its unique character.

Though no volume this size can tell the entire story, the images in this book showcase the many places, people, and events that have shaped Carroll County.

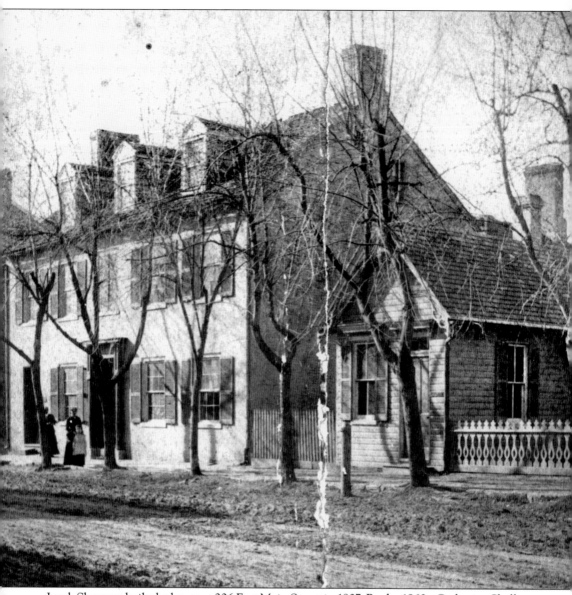

Jacob Sherman built the house at 206 East Main Street in 1807. By the 1860s, Catherine Shellman and her four children—Fanny, Harry, Mary, and James—lived in the house. Mary Shellman remained in the house until shortly before her death in 1938. In 1939, a group of local citizens formed the Historical Society of Carroll County to preserve the house and Carroll County history. (HSCC.)

One

WESTMINSTER

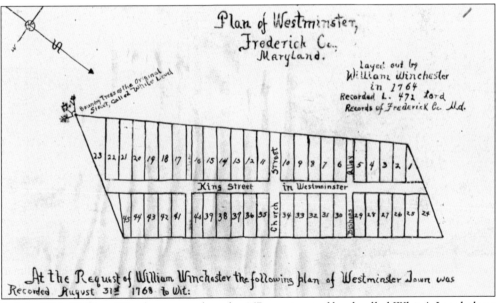

Plan of Westminster,
Frederick Co.,
Maryland.

Layed out by
William Winchester
in 1764
Recorded L. 471 Ford
Records of Frederick Co. Md.

Boundry Trees of the Original
Street, called White Level

King Street in Westminster

At the Request of William Winchester the following plan of Westminster Town was
Recorded August 31st 1768 to Wit:

In July 1754, William Winchester purchased a 167-acre tract of land called White's Level along Little Pipe Creek. In 1764, Winchester divided 16 acres on the northern part of White's Level into 45 lots. He laid out the lots along the main route to Baltimore (designated "King Street") and three smaller cross-streets (Bishop Alley, Church Street, and Store Alley). The first lots were sold the following year, and by 1768, when Winchester filed the above plan with the state, all the lots had been sold. Though in common usage the town was often referred to as "Winchester's Town," Winchester officially named his town "Westminster" after his home in England. Around the time of the American Revolution, King Street was renamed "Main Street." Store Alley eventually became known as "Ralph Street," but Bishop Alley and Church Street retain their original names. (HSCC.)

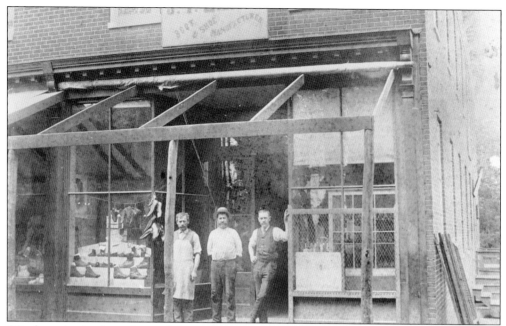

Winchester's sale of town lots and the construction of the courthouse encouraged early development along the east end of Main Street. In 1854–1855, Jacob Reese constructed a large brick store on the northwest corner of Main and Court Streets. By the late 19th century, J. T. Zahn, Shoe and Boot Manufacturer, occupied the store. From left to right in this photograph are Charles Stonesifer, John Beaver, and John Zahn. The building still stands. (HSCC.)

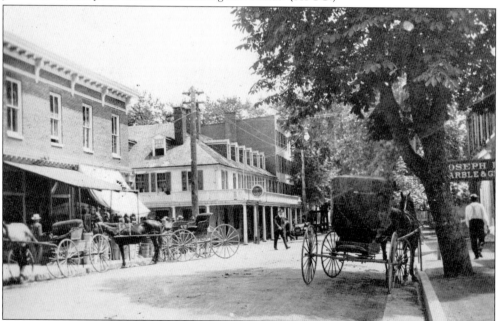

On the opposite corner stood the old City Hotel with its wide, shady veranda. In 1863, it served as a temporary hospital for those wounded at Gettysburg. The building, later known as the Main Court Inn, was torn down in the 1940s. Visible at the right of this photograph, taken between 1907 and 1909, is Joseph L. Mathias, Manufacturer and Dealer in Marble and Granite. (HSCC.)

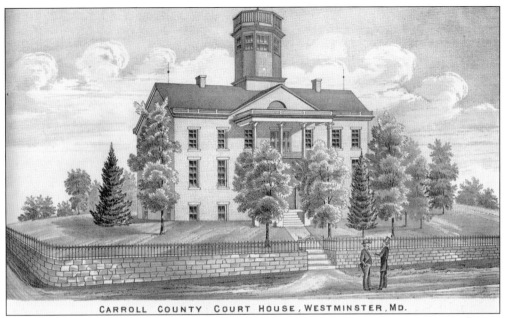

CARROLL COUNTY COURT HOUSE, WESTMINSTER, MD.

The legislation establishing Carroll County required the new county to construct a courthouse, jail, and almshouse. Isaac Shriver donated the land for the new courthouse, and Col. James M. Shellman designed the Greek Revival building, to which a cupola and portico were added. The first session of the circuit court was held in April 1837 at 216 East Main Street (later Cockey's Tavern). (HSCC.)

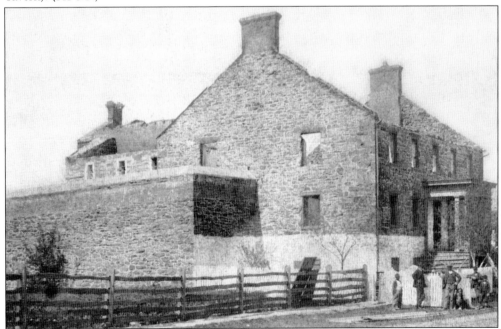

The jail, completed in 1837, housed prisoners and also served as the home for the sheriff and his family. A May 1882 fire, believed to have been set by prisoners, destroyed the roof and most of the interior of the building. This photograph of the fire damage is the earliest known image of the building. The jail was repaired and remained in use until 1971. (HSCC.)

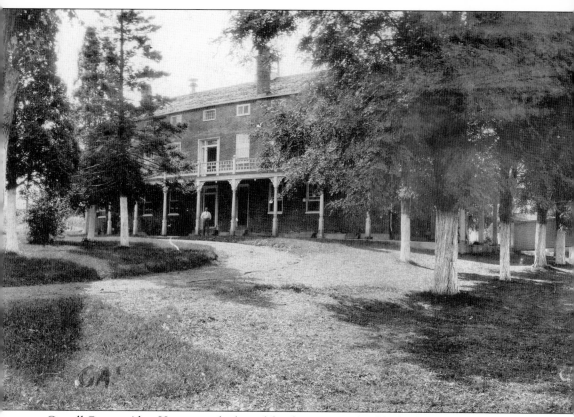

Carroll County Alms House was the last of the three required public buildings to be constructed. County-operated almshouses provided shelter and work for the local needy. Carroll County purchased 307 acres of the old White's Level property for the county farm. The dormitory-style main building, completed in 1852, was home to local "inmates," the almshouse steward, and his

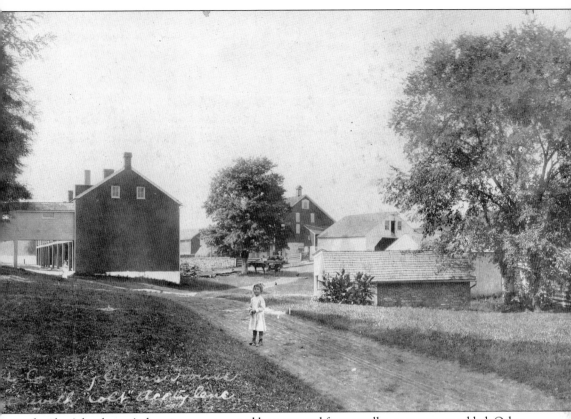

family. A brick men's dormitory, connected by a covered frame walkway, was soon added. Other structures on the property supported agricultural activities, hence the familiar name of "County Farm" for the property. Federal social programs of the 1960s made the almshouse obsolete. Today the property is home to the Carroll County Farm Museum. (HSCC.)

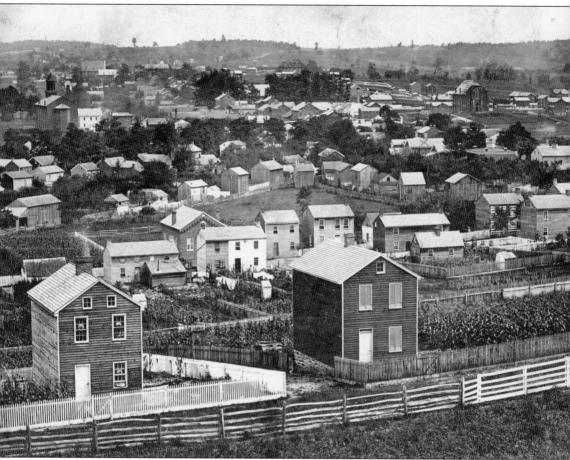

This extraordinary image, taken from the top of College Hill, is one of the earliest known views of Westminster. By the time this image was taken in the late 1860s, Westminster had grown tremendously and become a large, prosperous commercial center. Homes and businesses stretched west on Main Street all the way to College Hill. The hilltop had once been called the "Old Commons" and been the site of the annual Fourth of July celebration. In 1863, the First Delaware Cavalry camped on the commons during the Gettysburg campaign. In 1866, the first building of Western Maryland College was constructed on the site. In the right background of this image is St. Paul's United Church of Christ, still under construction, its roof covered with boards and its steeple not yet completed. In the left background, the rear of the original Grace Lutheran Church can be seen. The foreground shows the kitchen gardens and outbuildings that were vital to every home but were rarely photographed. (HSCC.)

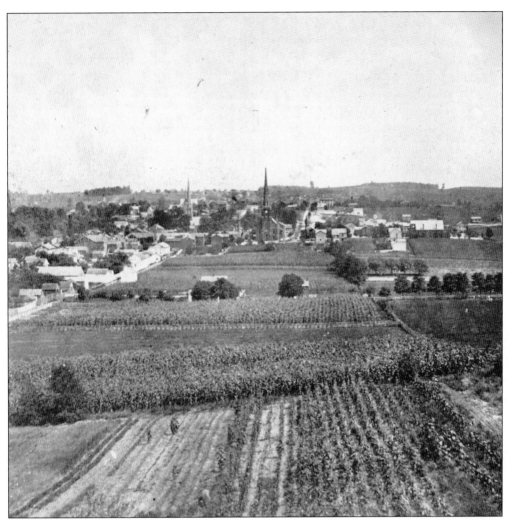

This stereoview from the 1870s was taken just a few years after the image on the preceding page. Looking east, Main Street can be seen to the left. In the center rises the steeple of the completed St. Paul's United Church of Christ at the corner of Bond and Green Streets. At this time, Green Street (at the center of the image) ends at Bond Street, and farm fields stretch right to the edge of the city. To the left of St. Paul's is the steeple of St. John's Roman Catholic Church on Main Street, now the site of the Westminster branch of the Carroll County Public Library. In the distance on the right stands the mansion built by Col. W. W. Dallas. Dallas, once the owner of Trevanion (near Taneytown), left Carroll County during the Civil War but returned after the war's end and constructed a massive Second Empire–style house on Green Street, near the intersection with Center Street. From 1918 to 1936, the Dallas mansion served as an elementary school. (HSCC.)

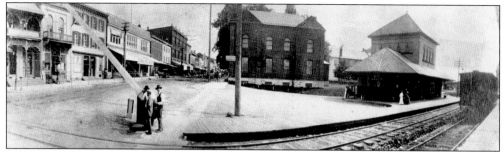

The railroad came to Westminster with the arrival of the Western Maryland Railroad in 1861. The tracks crossed Main Street at an angle near Liberty Street. Soon factories grew up along the tracks and hotels sprang up around Westminster to accommodate the travelers arriving by rail. This panoramic view looking east on Main Street was taken *c.* 1900 and shows the railroad crossing with the passenger station at right. (HSCC.)

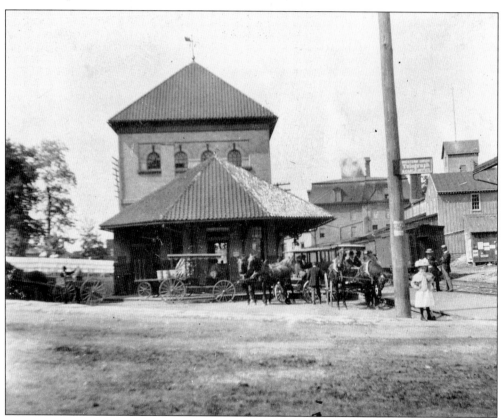

The new Western Maryland Railroad passenger station in Westminster opened in 1896 to great acclaim and quickly became a center of activity. In this 1900 photograph, seven-year-old Treva Yeiser (wearing a new hat) waits on the platform to bid farewell to her father, George W. Yeiser of Union Mills. Yeiser closed his store for five months in 1900 and set off on a voyage to the Holy Land. (HSCC.)

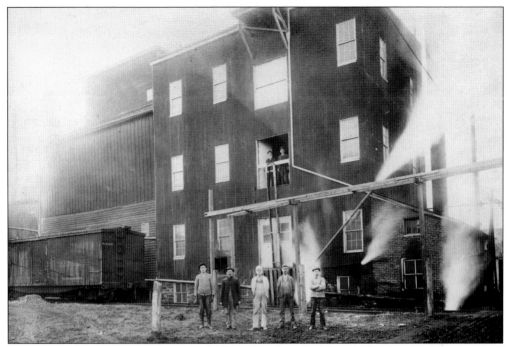

Factories and warehouses grew up beside the railroad tracks. Many had railroad sidings (spurs off the main line) that allowed trains to pull up next to the building for easy loading and unloading of goods and supplies. Seen here is the N. I. Gorsuch and Son Company mill on West Main Street in January 27, 1913. (HSCC.)

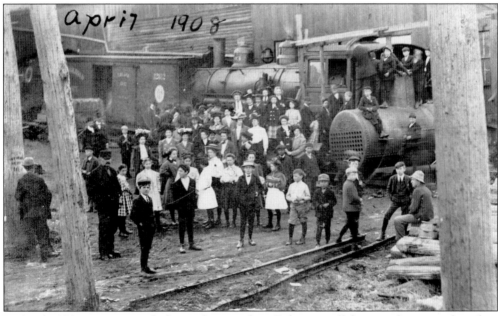

In April 1908, an open switch diverted a train from Baltimore off the main line onto the siding at the Gorsuch mill. The train crashed into several boxcars parked on the siding. Though the boxcars were destroyed, they absorbed most of the force of the crash, preventing the train from crashing into the mill. Luckily none of the train's passengers were seriously hurt. (HSCC.)

This 1866 view shows the intersection of Main and Liberty Streets at the crossing with the Western Maryland Railway. At the right is St. John's Catholic Church, still under construction, its steeple covered with boards. In the distance at the left is the steeple of the Methodist Protestant Church, which stands farther east on Main Street. With the dirt streets, the railroad crossing is barely noticeable. (HSCC.)

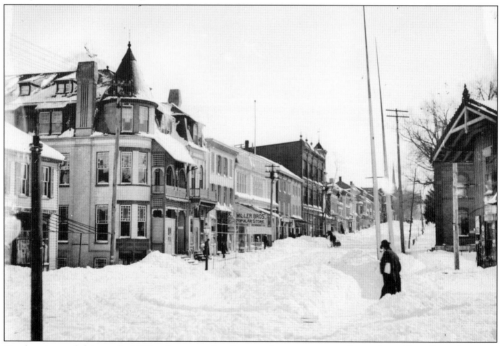

By the time of this early-1890s photograph, the northeast corner, where the railroad tracks cross Main Street, had become occupied by the Albion Hotel. The distinctive Queen Anne–style hotel was designed by Baltimore architect Jackson C. Gott and constructed in 1886. In the center of the block can be seen the distinctive finials atop the Wantz building, later the home of Mather's department store. (HSCC.)

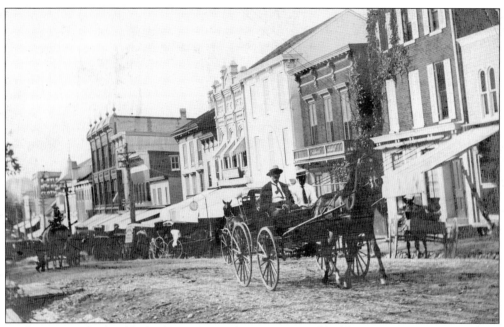

Farther east on the first block of Main Street, large commercial buildings gave way to smaller stores and residences. Vehicles traveling on Westminster's unpaved streets raised a cloud of dust in dry weather and churned the streets into mud in wet weather. In this 1902 image, Henry Harbaugh drives east on Main Street, while behind him, a sprinkler wagon dampens the dirt street to keep the dust down. (HSCC.)

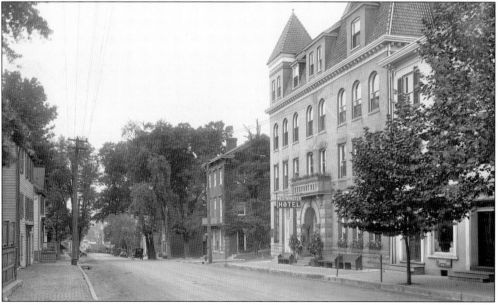

At 117 East Main Street stood the Charles Carroll Hotel. Built in 1898 by George W. Albaugh, the hotel (later the Westminster Hotel) stood out for its yellow brick walls and Spanish tile roof. Guests marvelled at the electric lights, elevators, and porcelain baths. Part of the ground floor housed the Westminster Deposit and Trust Company. Though the hotel closed, the building remains as a bank. (HSCC.)

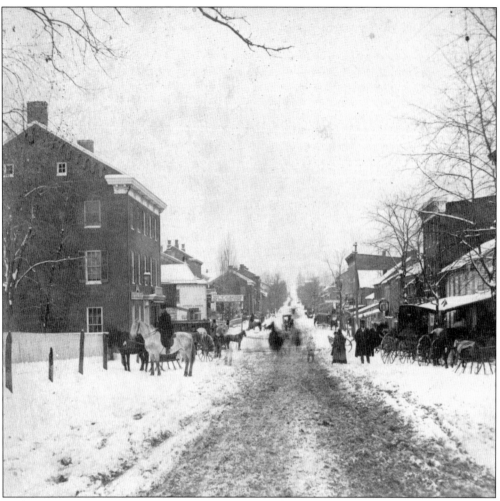

This rare stereoview from the early 1870s shows Main Street on a winter day. The photographer was standing on East Main Street, approximately in front of St. John's Church. The large brick building in the left foreground stands on the site that would later be occupied by the First National Bank. George W. Albaugh's One Price Store is at the center left, just beyond the railroad tracks. On the right side of the street, neither the Albion Hotel nor the Babylon Building have been constructed yet. West Main Street disappears in the distance, rising up College Hill. Snow covers the sidewalks and sides of the street, but traffic has churned the center of the street into a slushy mess, making driving and walking difficult. (HSCC.)

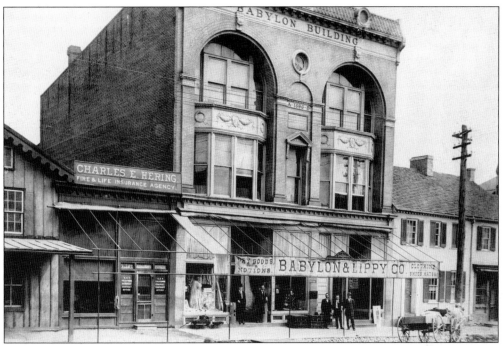

In 1896, Thomas F. Babylon, president of the Babylon and Lippy Company, built the three-story Babylon Building on the north side of West Main Street, just beyond the railroad crossing. This image was taken shortly after the building's construction. (HSCC.)

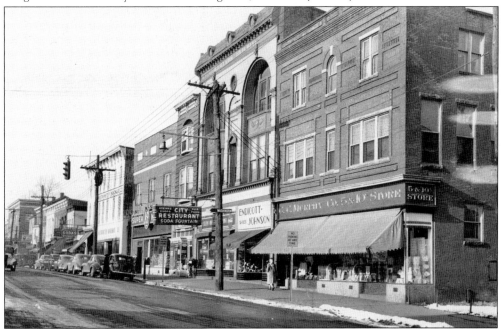

By the time this photograph was taken in the 1950s, the first block of West Main Street had changed significantly. The Rosenstock family constructed the large corner building for their clothing store and a pool hall. G. C. Murphy 5¢ and 10¢ Store occupied the building from 1940 to 1980. In the Babylon Building are Endicott-Johnson shoes and the City Restaurant. (HSCC.)

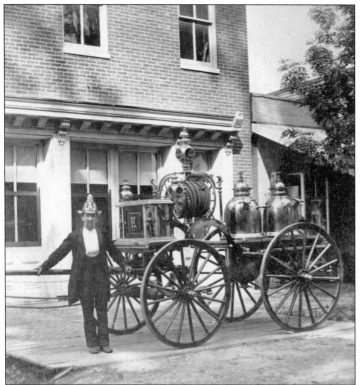

In 1879, the Westminster fire department incorporated as Westminster Fire and Hose Company, No. 1. The company used the building at 31 East Main Street to house a hook and ladder truck and the chemical fire engine seen here. The chemical engine was retired in 1885 when the city water system was completed, allowing firefighters to connect directly to a water source. (HSCC.)

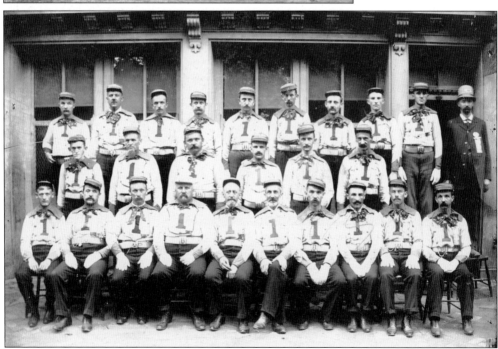

In 1895, the members of the Westminster Fire Department posed for one last photograph in front of the old fire station at 31 East Main Street. The firemen then paraded to the new station a short distance away. (Courtesy of Anne Franklin Boyle Alexander.)

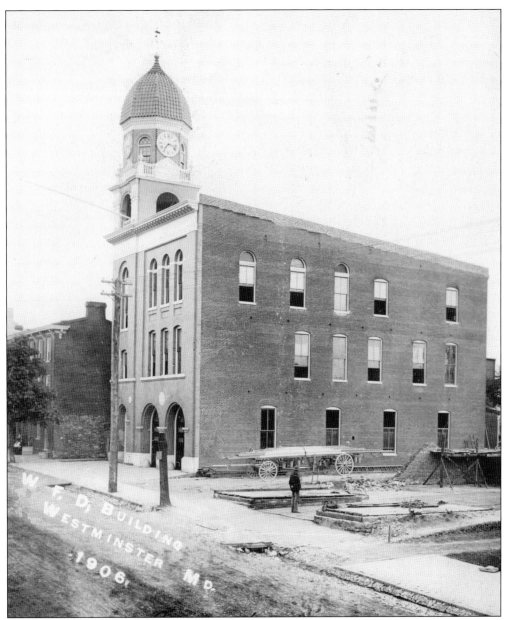

Built in 1896, the old firehouse on East Main Street dominates Westminster's skyline, rising to a height of 92 feet. Baltimore architect Jackson C. Gott, who had designed the Albion Hotel 10 years earlier, created a handsome three-story building featuring a facade of buff-colored brick with marble medallions commemorating the dates of the fire company's founding and construction of the building. The tower is topped by a Seth Thomas clock donated by Margaret Cassell Baile at a cost of over $1,000. The weather vane atop the tower included a fireman's helmet at its center. The building housed the fire company's equipment on the first floor with a banquet hall, offices, meeting rooms, a lending library, and the city council chambers on the upper floors. This image was taken in 1906, shortly after a fire destroyed the adjacent Palace Livery Stable. A three-story addition was constructed on the west side of the firehouse in 1927. The fire company moved to a new facility on John Street in 1998. (HSCC.)

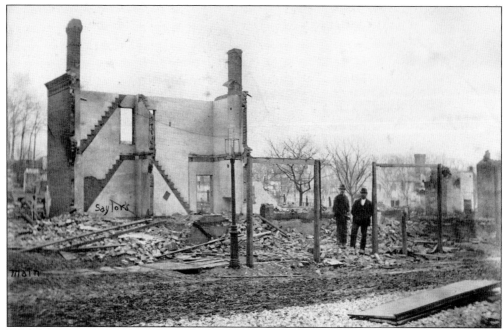

Tragedy struck Westminster on April 9, 1883, when Jacob Thompson's livery stable on West Main Street caught fire. The alarm sounded about 11:30 p.m. By the time the firemen arrived, the stable was fully engulfed, and a strong wind was spreading the flames to neighboring structures. At the time, Westminster had no city water supply, and firemen fought the blaze with their chemical engine and water carried from nearby wells. The fire destroyed 16 houses, Grace Lutheran Church on Carroll Street, two manufactories, and eight stables. Seventeen families and 13 businesses were left homeless. Total fire damage was estimated at $135,000. Two men who had been sleeping on the second floor of the stable where the fire began perished, as did a number of horses and cattle. Fortunately the city learned from the tragedy and eventually installed water lines and fire hydrants. (HSCC.)

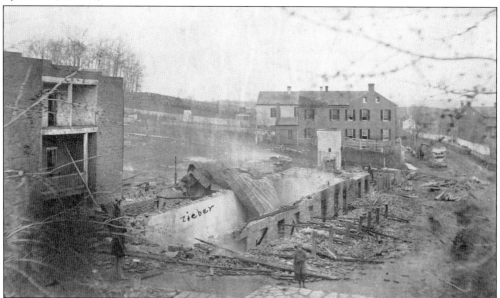

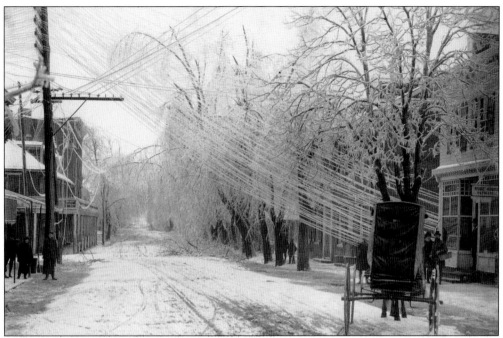

Weather has also had a devastating effect on the city over the years. On February 21, 1902, Carroll County suffered what the *American Sentinel* called "the Great Sleet Storm." Two inches of hail, followed by heavy rains, resulted in ice accumulating on trees and power lines. In Westminster, the storm damaged two-thirds of the poles belonging to the Western Maryland Telephone Company. Streets such as Main (above) and Court (below) were almost impassable due to downed branches and wire. Westminster photographer James D. Mitchell captured these images and others, which the *Democratic Advocate* ran on its front page. (HSCC.)

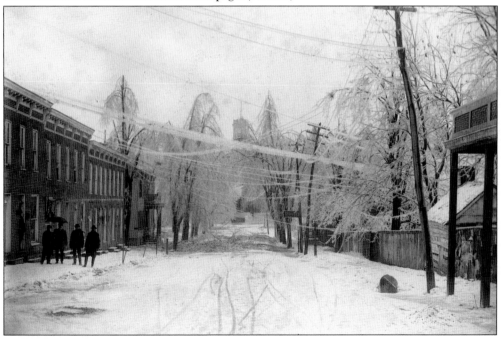

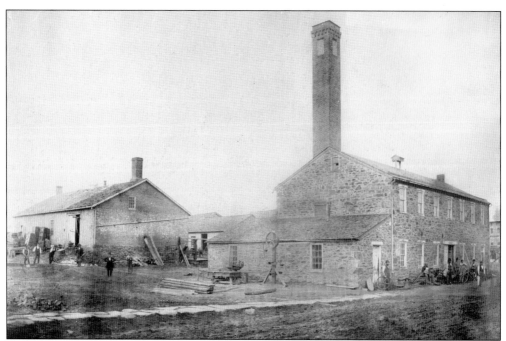

This stone building on Liberty Street is one of Westminster's landmarks. The building housed a number of factories during the 19th century, such as the Wagner Manufacturing Company, seen here. The B. F. Shriver Canning Company bought it in 1881 to expand their operations but moved out around 1901. The United Machinery Company was the occupant by the 1920s, when this motorcycle group posed on Liberty Street. The building has recently been restored. (HSCC.)

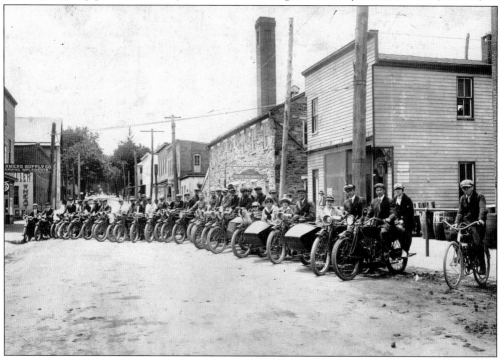

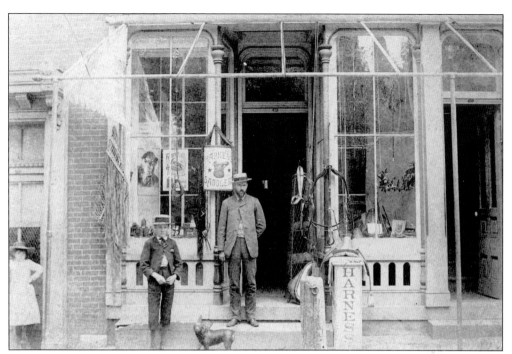

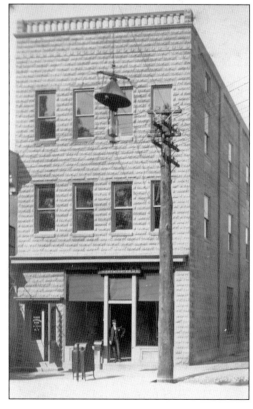

Shunk's Saddlery (above), seen here c. 1870, stood at 39 East Main Street. From left to right in this photograph are Lilie Johnston, Eugene Tubman, store owner Jacob Walter Shunk, and Tripp, the dog. The building was demolished in the 1890s to make way for a new post office (right). The unusual stone structure was built during the tenure of postmaster Joseph B. Boyle, who served as Westminster's postmaster during the administrations of Pres. Grover Cleveland. Previous to the construction of this building, the post office was located farther west on Main Street in the Wantz building. (HSCC.)

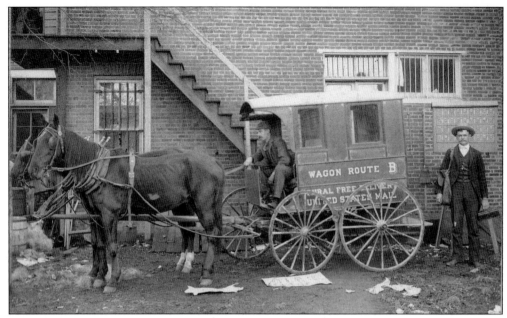

The United States Post Office selected Carroll County for the first rural free delivery service in the country thanks to the efforts of Edwin W. Shriver. His county-wide delivery system relied on a postal wagon of his own design called the "Post Office on Wheels." Shriver made his first test run on April 3, 1899. In this image, clerk Atlee Wampler and driver Charles Swartzbaugh prepare to leave on their route. (HSCC.)

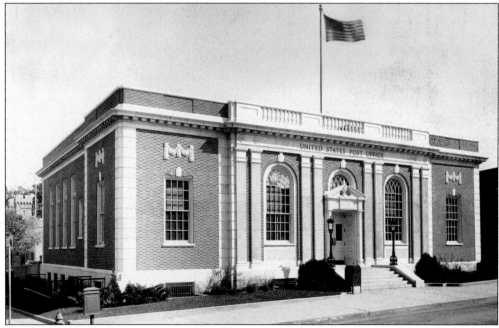

Westminster's old post office was replaced in the 1930s with a large new building on the opposite corner. Work began in early 1932, and the cornerstone was laid on November 30. The new building opened in August 1934. The building was expanded over the years before being replaced by a larger facility. (HSCC.)

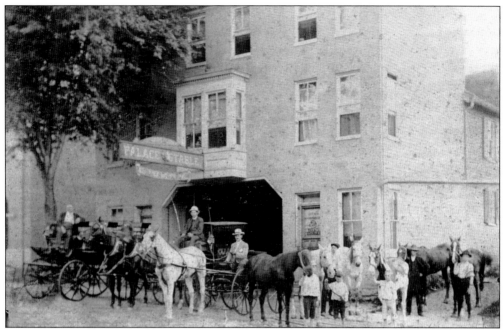

Livery stables provided Westminster's residents with a place to stable their horses or rent horses and vehicles. Among the best known was Harry Harbaugh's Palace Livery Stable on Main Street, next to the firehouse. On April 6, 1906, fire roared through the stable, destroying the building, killing several horses, damaging the adjacent firehouse, and leaving Harbaugh's family homeless. (HSCC.)

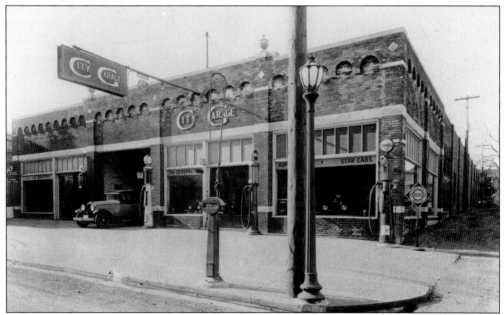

As the automobile took over the streets of Westminster, livery stables were replaced by garages and car dealerships. The City Garage at 116–120 East Main Street celebrated the glory of the automobile age. Though not very large, the building was exuberantly decorated with Romanesque pilasters, arches, and urns. (HSCC.)

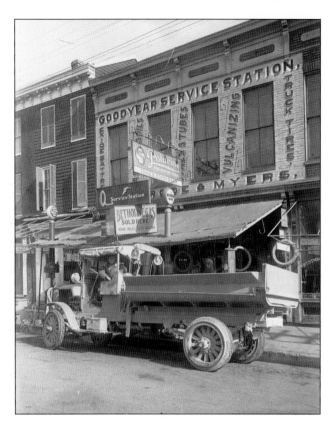

Service stations became necessities as cars became popular. This 1930s image shows an early tow truck in front of the Eckenrode and Myers Goodyear Service Center, which sold not only tires but also Exide batteries, Havoline oil, and Betholine gas, which advertised "More Miles Less Gallons." (HSCC.)

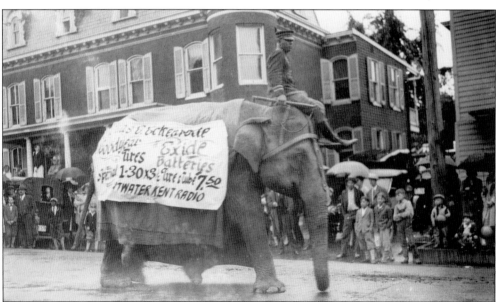

Circus parades, such as this one on Main Street in the 1920s, helped the show announce its arrival, pique the public's curiosity, and increase attendance at its performances. This circus also earned some extra money by selling advertising space to a local business—the sign on the elephant advertises the Exide batteries and Goodyear tires available at the Eckenrode store. (HSCC.)

Two

HAMPSTEAD

In 1786, Christopher Vaughn laid out 16 town lots on part of a land tract called Spring Garden. Vaughn named the new town Hampstead but, since half the lots were sold to members of the Cox family, it was often referred to as "Coxes' Town" or "Coxville." Stages and freight wagons passed through the town on the road from Baltimore to Carlisle that had been laid out by Richard Owings in 1737, and in 1796, Peter Frank opened a tavern. Hampstead grew into a market center, with local farmers coming to ship their produce to Baltimore and buy goods brought in from the city. The arrival of the railroad brought new residents, businesses, and prosperity. The town incorporated in 1888. This map is from the 1877 *Illustrated Atlas of Carroll County*. (HSCC.)

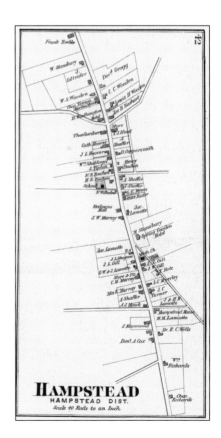

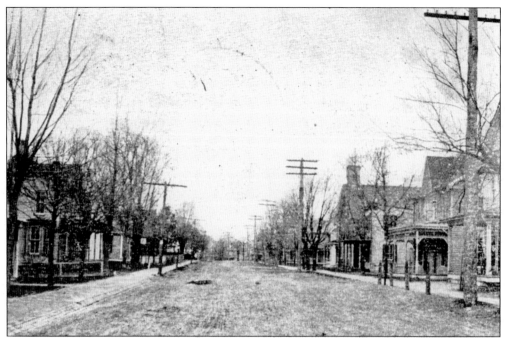

Hampstead is a long, narrow community. At the time of its incorporation, it was 6,500 feet long with only 38 buildings. Homes, businesses, and churches stood side by side along Main Street. Several roads intersected Main Street, but other than small alleys, no roads would parallel it until well into the 20th century. These postcards titled "North Main Street" (above) and "Central Main Street" (below) show the town in the early 20th century. Though a major artery from Baltimore to Pennsylvania, the street at this time has not yet been paved, and travel could be difficult in wet or snowy weather. The telephone poles seem out of place, but by 1910, there were 185 telephone customers in Hampstead. (HSCC.)

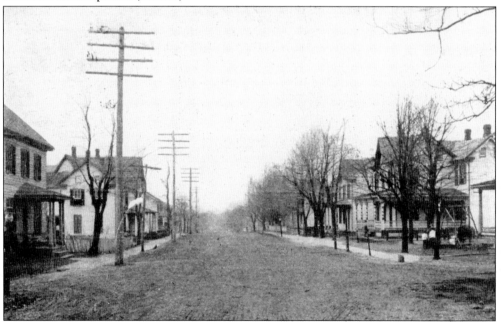

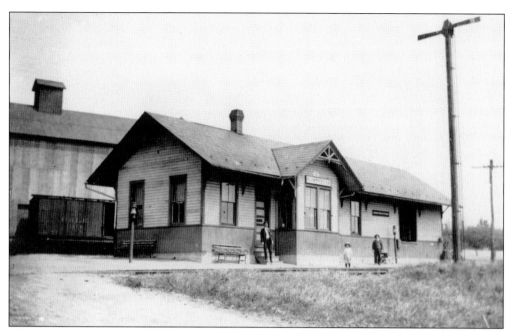

The railroad came late to Hampstead. The tracks of the Baltimore and Hanover Company were not completed until 1879, connecting with the Bachman Valley Railroad at Lineboro. Pres. Calvin Coolidge traveled this route through Hampstead on his way to deliver a Memorial Day address in Gettysburg in 1928. The station on Gill Avenue was constructed in 1912, replacing a grain elevator and small freight and passenger stations. (Courtesy of Bob Porterfield.)

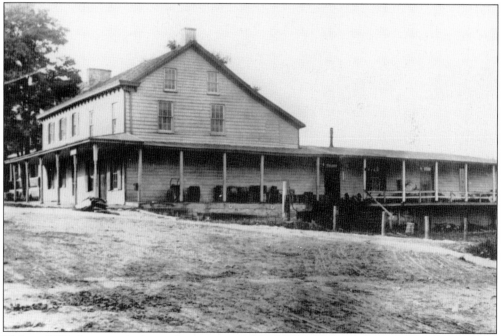

This *c.* 1900 photograph shows the store owned by J. W. Murray at the corner of South Main Street and Gill Avenue. The structure dates to the early 19th century and had once housed a freight depot and the town's first post office. (Courtesy of Bob Porterfield.)

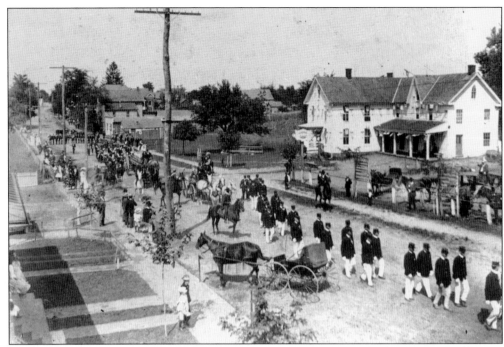

The Spring Garden Hotel on the east side of Main Street was reputed to be the first building in Hampstead. When John W. Bond bought the business in 1892, its rooms were described as well lighted and ventilated. This image of a fireman's parade was taken on September 28, 1902. The hotel was demolished in the 1970s. (Courtesy of Bob Porterfield.)

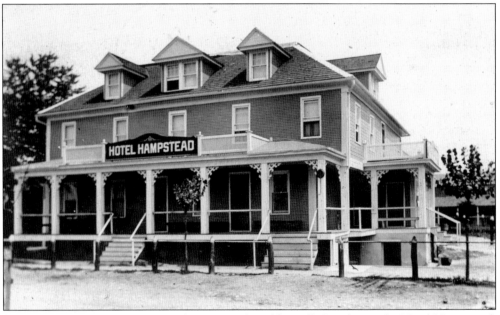

Farther north on Main Street, at the corner of Beckleysville Road, was the Hotel Hampstead. Thought to have been built in the late 19th century, the business passed through a number of owners. In 1905, Albert Buchen sold it to Lamada Stick, who ran the hotel until 1923. The building still stands but is not longer a hotel. (HSCC.)

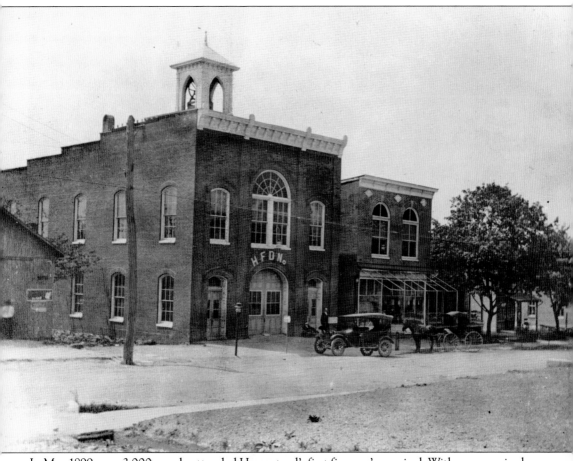

In May 1899, over 3,000 people attended Hampstead's first firemen's carnival. With money raised by the event, the town purchased a hook and ladder truck, its first firefighting apparatus. The Hampstead Volunteer Fire Engine and Hose Company No. 1 was chartered the following year. The company constructed a large, brick firehouse on Main Street that was dedicated in 1903. Horse-drawn equipment was used until 1918, when the first mechanized apparatus was purchased. Emergency medical services were added in 1946 with the purchase of the first ambulance. As more equipment was acquired, the department outgrew its facilities and moved to a new firehouse in 1975. The building to the right of the firehouse in this 1920s photograph was the store owned by Howard R. Lippy. (Courtesy of Bob Porterfield.)

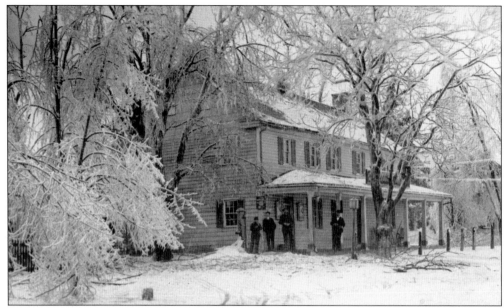

At 111 Main Street stood a log structure built in the early 19th century. By the time of this c. 1905 photograph, it was known as Sapp's Tavern. Charles and Mary Ella Sapp purchased the building in 1903 and operated an inn and tavern for many years. When the building was demolished in 1949, the Rotary Club salvaged the logs to construct a cabin for the Boy Scouts. (Courtesy of Bob Porterfield.)

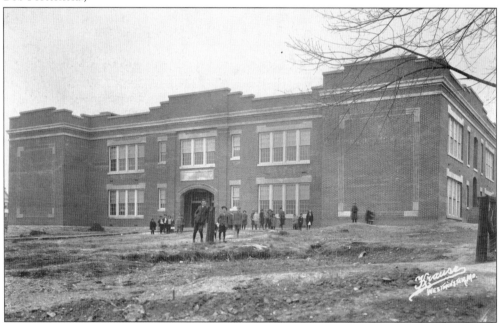

In June 1916, Hampstead petitioned Carroll County to "erect an up to date" school. The brick, two-story building shown was completed in 1918 and housed students in grades 1 through 12. The school was expanded in 1939 and again in 1968. The high school students moved to a separate facility in 1956. With the construction of a new elementary school in 1986, the old building closed. (HSCC.)

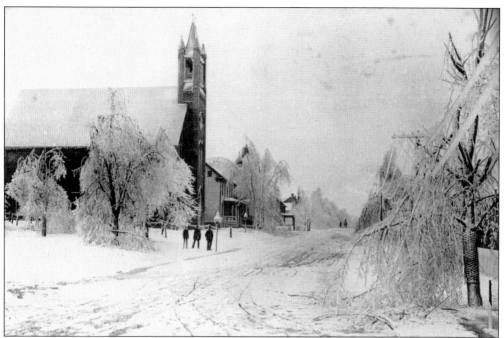

Carroll County has suffered many devastating storms. This view, looking south on Hampstead's Main Street, was probably taken in February 1902 after an ice storm crippled the county. At left is St. John's Methodist Church. (Courtesy of Bob Porterfield.)

This photograph from the late 1940s shows the intersection of Main Street and Gill Avenue. The large stone building at the left is the Hampstead Bank, which was established in 1900. Next to the bank stands the post office. Farther down the block, the Central Grocery, Central Theater, Porterfield's Drug Store, and the firehouse can be seen. (Courtesy of Bob Porterfield.)

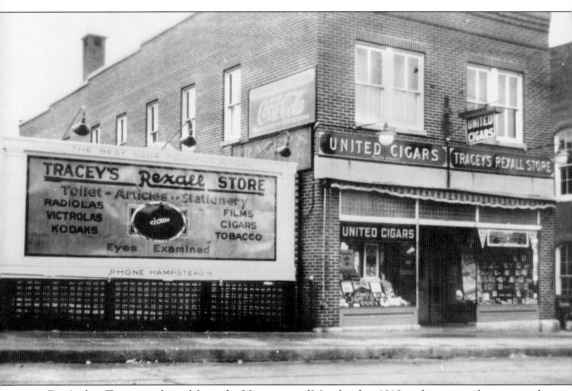

Dr. Arthur Tracey graduated from the University of Maryland in 1910 and two years later opened an optometrist's office and pharmacy in Hampstead. The building seen here was built in 1921. He was later joined in business by his daughter, Dr. Grace Tracey. While the pharmacy supported the family, Arthur Tracey's true love was history. In the 1930s, he began an extensive research project to trace the history of land transactions in Carroll and adjoining counties. Using original records in the state archives, he compiled information on 30,000 land tracts and their owners. His daughter assisted him with his research by typing and organizing an extensive card file on each tract and landowner. After her father's death in 1960, Grace continued the work until her own death in 1967. The Tracey collection now resides at the Historical Society of Carroll County. (Courtesy of Bob Porterfield.)

Three

MANCHESTER

Manchester stands at the intersection of two Indian trails: one connecting the Potomac and Susquehanna Rivers and the other connecting Conewago (Hanover) to Patapsco (Baltimore). In 1765, Capt. Richard Richards purchased a 67-acre tract called New Market and laid out 122 town lots. He named the settlement Manchester after his home in England. Taverns quickly appeared to accommodate the travelers and wagon drivers passing through the town. Many early residents were Germans who moved south from York County in Pennsylvania. A favorite German food was noodles, made by hand and hung outside to dry. This common sight gave the town its nickname, "Noodle Doosey." This map is from the 1877 *Illustrated Atlas of Carroll County.* (HSCC.)

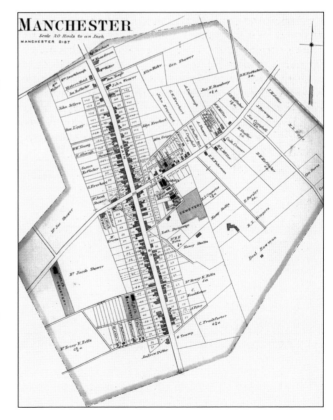

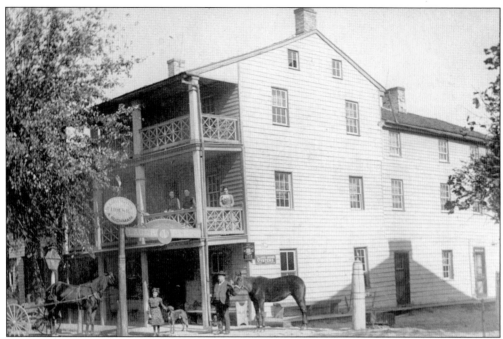

During the 19th century, the taverns that had accommodated early travelers grew into larger hotels. Seen in this *c.* 1900 photograph is the Washington House, Archibald Buchman, proprietor. It was built near the center of town on Main Street in the early 19th century. One of the town pumps stands at the right side of the building. (Courtesy of the Manchester Historical Center.)

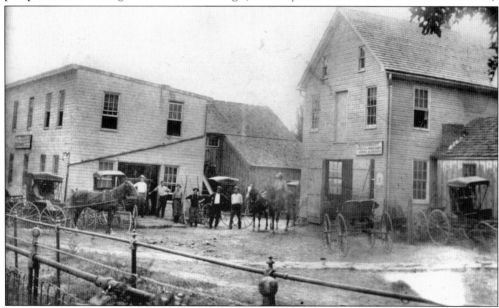

Tradesmen were vital to the community. To the left in this 1890s image is the shop of William Bergman and Sons, carriage makers, and to the right is G. D. Barnhart, "Practical Horse Shoer and General Blacksmith," as the sign on the building reads. The shops stood at the intersection of Long Lane and Church Street. The parking lot for Immanuel Lutheran Church now occupies the site. (Courtesy of the Manchester Historical Center.)

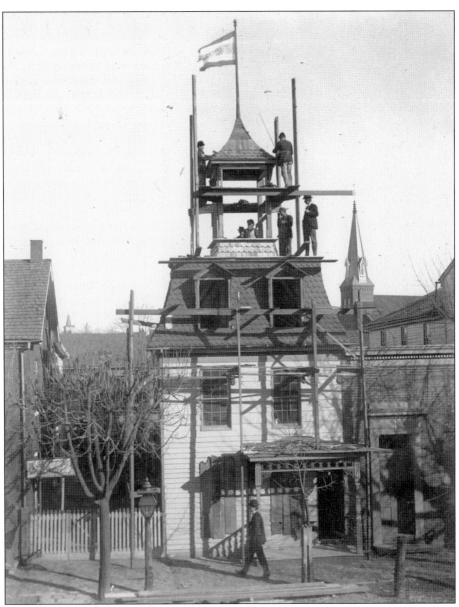

The Manchester Fire Engine and Hook and Ladder Company No. 1 was organized in 1885. The company operated out of an old school on York Street until the construction of a new firehouse on North Main Street in 1898. This image, taken December 29, 1898, shows workmen finishing the roof on the cupola. Tragically the firehouse was destroyed when fire swept through the city on June 21, 1921. The *Democratic Advocate* reported "Headquarters of the Manchester Fire Engine and Hook and Ladder Company, the office of the Dug Hill Fire Insurance Company, seven residences, a garage, four barns, seven automobiles, one motorcycle, the outbuildings of three homes, a horse and three hogs were destroyed, and a large building occupied by the Manchester bank and store, one dwelling and the public school were damaged." The Manchester firemen had exhausted their supply of firefighting chemicals the day before at a fire in Hampstead and had nothing left with which to save their town. A new masonry firehouse was erected in 1925 and expanded in 1948. (HSCC.)

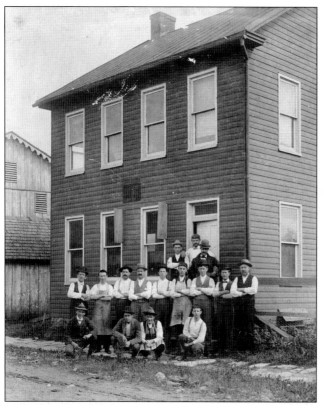

For many years, cigar manufacturing was a major industry in Manchester. The factories, the first of which opened shortly after the Civil War, primarily used tobacco grown in Carroll County. According to the Maryland Agricultural Survey of 1880, the county's 88 growers produced over 134,000 pounds of tobacco in 1879. Making cigars was a labor-intensive process, and the factories employed many of the town's men, women, and children. Most of the factories were located in small frame buildings, such as the Masenheimer cigar factory on north Main Street (above). This rare interior photograph (below) from the early 20th century shows the workers at Handy's on South Main Street. (Top: HSCC; bottom courtesy of the Manchester Historical Center.)

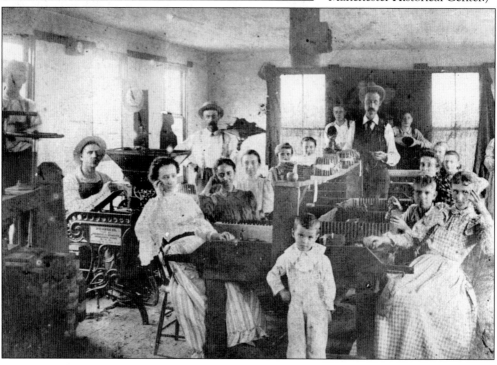

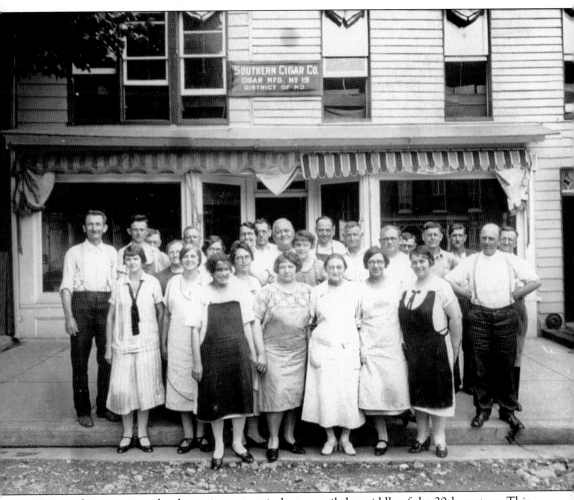

Cigarmaking continued to be an important industry until the middle of the 20th century. This photograph shows the Southern Cigar Company, District of Maryland. From left to right are (first row) Willa Abbott, Ruth Leese, Tootie Burgoon, ? Therit, Bertha Rusk, Cecilia Buchman, Amelia Masenheimer, Laura Burgoon, and John Adkins; (second row) Horatio Leese, Ray Abbott, Renee Loats, Simon Shultz, unidentified, Elva Erb, George Rush, Jake Warehime, Goldie Lippy, Albert Brilhart, unidentified, Eddie Burgoon, Elmer Lippy, Temp Menchey, and Billy Hoffman. By the 1930s, machines took over many of the steps in the manufacturing process, and the Manchester factories closed when they could not afford to modernize their facilities. (Courtesy of the Manchester Historical Center.)

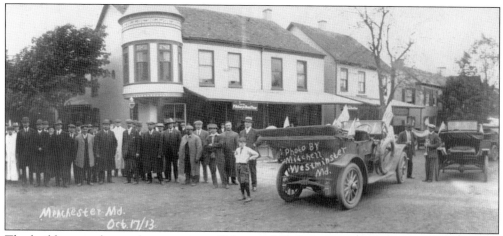

The building on the southeast corner of Main and York Streets stands out for its distinctive corner turret. In the 1870s, it was home to D. Hoffacker's Sons general merchandise store, reputed to be the largest in Carroll County. A number of stores have called the building home. This photograph from October 17, 1913, shows an automobile tour of Carroll County. (Courtesy of the Manchester Historical Center.)

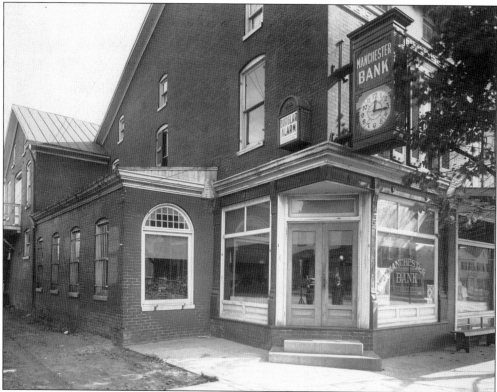

John Masenheimer traveled to work in Westminster every day, and friends often asked him to do their banking while he was in the city. To meet this need, he established the Manchester Bank of Carroll County in 1899. During its early years, the bank did business in the Shower building at the corner of York and Main Streets. A new building (seen here), designed by Baltimore architects Buckler and Fenhagen, was constructed in 1929. (HSCC.)

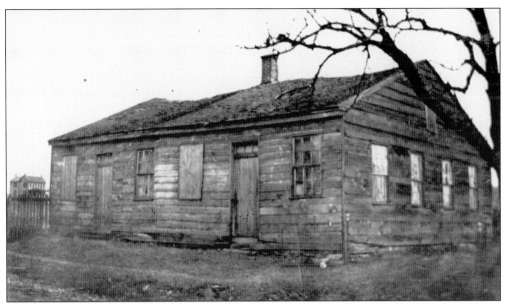

This small frame building served as the first public school in Manchester. The date of its construction is not known. In the early years, parents paid between 25¢ and $1 per student per term. Tuition charges ended with the establishment of the Carroll County public school system in 1865. In 1878, the structure was moved and a new, four-room brick school erected on the site. (Courtesy of the Manchester Historical Center.)

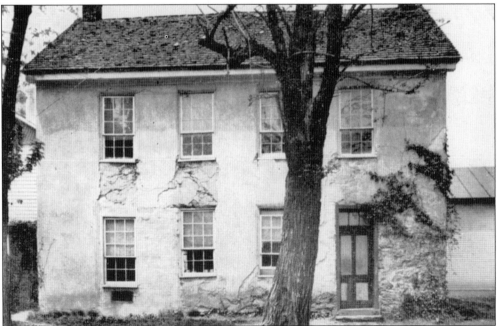

The private Manchester Academy opened on York Street in 1831. Tuition fees ranged from $2 to $5 depending on the course of study. The school closed during the Civil War and never reopened. Beginning in 1922, the old academy—with some temporary portable additions—housed high school students. This arrangement lasted until a new high school opened in 1932. (Courtesy of the Manchester Historical Center.)

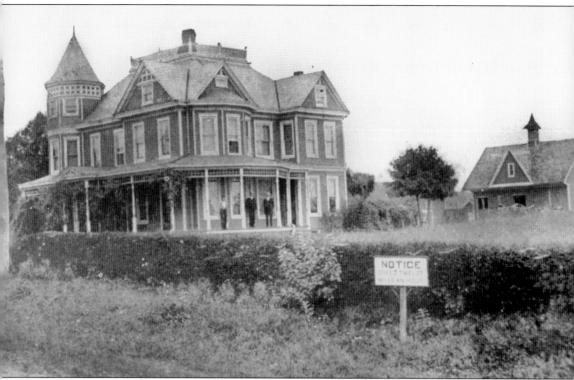

Dr. Jacob H. Sherman had his home and office on North Main Street in a large house today known as Long View Nursing Home. During the Great Depression, Sherman sold the building to Dr. Robert F. Wells. Wells's daughter-in-law, Kathleen, was a registered nurse. After Dr. Wells's death in 1944, Kathleen and her husband, who was gravely ill, moved into the Manchester house. She began taking in additional patients to help support the family, and in September 1946, received a license to operate a nursing home, the first in Carroll County. She continued to operate the nursing home after her husband's death in 1948 and owned the facility until 1962. The original house has been greatly expanded over the years. (Courtesy of the Manchester Historical Center.)

Four

MOUNT AIRY

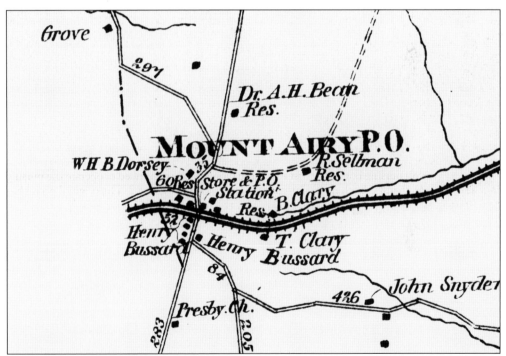

Mount Airy sits in the far southwestern corner of Carroll County, straddling the Frederick County line. Perched on Parr's Ridge at an elevation of 830 feet, it is the highest point between Baltimore and Braddock Heights. The settlement of six families on the ridge in the 1830s marked the community's beginning. The arrival of the Baltimore and Ohio Railroad (B&O) assured the town's survival, and by the 1840s, Henry Bussard's tavern and a cluster of houses occupied the land along the tracks. Appropriately it was a railroad foreman who gave the town its name. His reference to the breezy site as an "airish mountain" led to the nickname Mount Airy. The name stuck, and the town incorporated under that name in 1894. This map is from the 1877 *Illustrated Atlas of Carroll County*. (HSCC.)

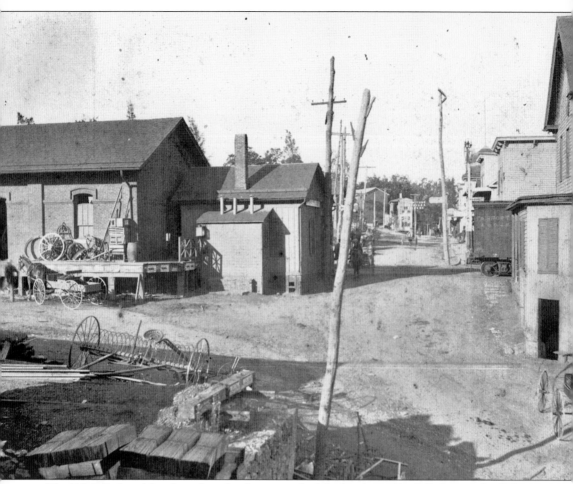

The B&O Railroad faced an obstacle when it reached the heights at Parr's Ridge, south of Mount Airy, in 1831. With its locomotives lacking the power to climb the ridge, the railroad constructed a set of four inclined planes to pull the trains up one side of the slope and down the other. New locomotives introduced in the late 1830s could handle heavier loads and steeper slopes. In 1839, the B&O constructed a new spur line that ran around the north side of the slope, avoiding the inclined planes, on a route the old locomotives could not have handled. The spur ran directly through Mount Airy. The railroad purchased a right-of-way from Henry Bussard and named him station agent. The freight station in this 1902 photograph was erected in 1875, replacing one from 1838. A passenger waiting room, out of sight to the left in this image, was added in 1882. By the early 20th century, six passenger trains a day came to Mount Airy. The last passenger train stopped in the town in 1949. (Courtesy of the Historical Society of Mount Airy.)

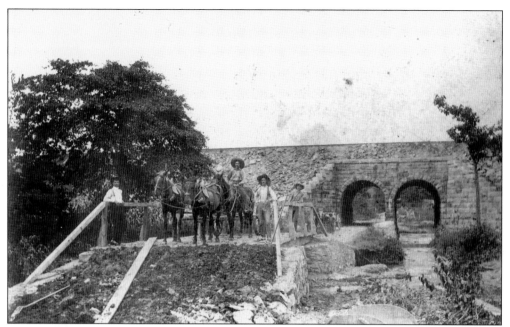

East of Mount Airy, the B&O tracks had to cross the Frederick Turnpike and a small creek beside the road. A masonry, twin-arch bridge was constructed with side-by-side spans for the road and creek. This photograph shows the construction of the new bridge in 1901 during the reconstruction of the Old Main Line. (Courtesy of the Historical Society of Mount Airy.)

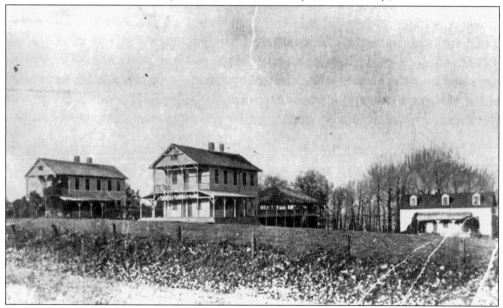

In 1888, the Robert Garrett Sanitorium opened in Mount Airy. Each June, children from the Robert Garrett Hospital for Children in Baltimore, primarily tuberculosis patients, left the city for the country. The sanitorium had a large dormitory, nurses' quarters, doctor's office, open-air pavilion, and cookhouse with boardwalks connecting the buildings. Parents received free transportation to visit their children. The hospital closed around 1930. (Courtesy of the Historical Society of Mount Airy.)

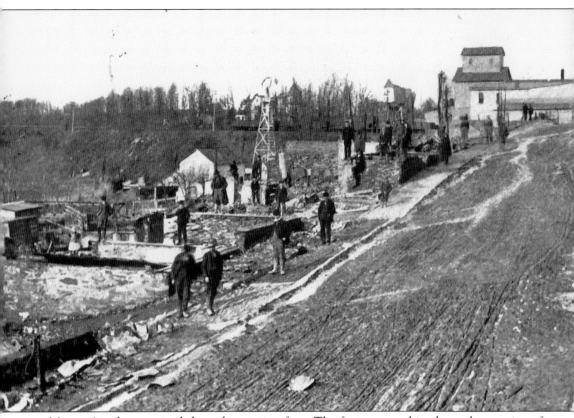

Mount Airy has survived three devastating fires. The first occurred in the early morning of February 24, 1903, and destroyed most of the businesses south of the railroad tracks (above). Among those lost were a grocery, bakery, butcher, furniture store, dry goods store, millinery shop, drug store, harness shop, and an insurance agency (which, unfortunately, was not fully insured for the loss). The widespread damage was partly due to the fact that there was no fire company to battle the flames. Fire struck again at midday on March 25, 1914, this time leveling much of the area north of the railroad tracks. There was still no local fire company, but help arrived by train from Frederick. On the evening June 4, 1925, disaster struck a third time, as fire again raced through the business district north of the tracks. In response to this fire, the city organized the Mount Airy Volunteer Fire Company and purchased a pumper. (Courtesy of the Historical Society of Mount Airy.)

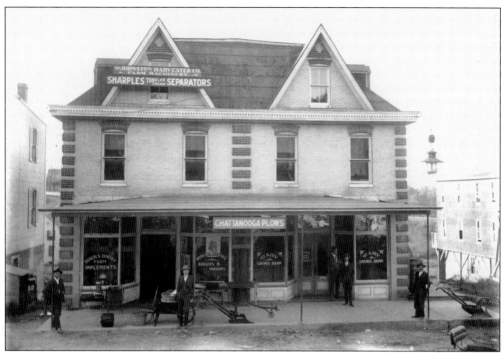

Byron S. Dorsey, Mount Airy's first mayor (1896–1904), opened his farm implements store in 1881. He erected the building seen in this 1908 photograph after his original store burned in the 1903 fire. Sharing the building in 1908 was the Mount Airy Savings Bank. The bank was established in 1908 and the following year moved into a building of its own. (Courtesy of the Historical Society of Mount Airy.)

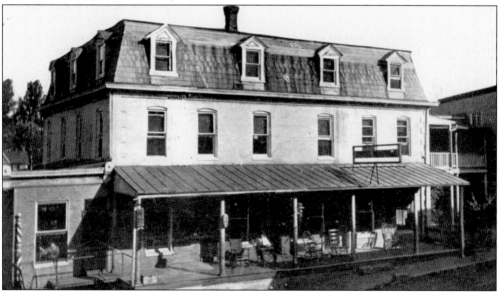

The resilient residents of Mount Airy rebuilt after each fire. C. E. Simpson's Hotel opened in 1902 but burned the following year. Simpson immediately erected a new masonry structure that the October 21, 1910, issue of the *Democratic Advocate* described as having "all the comforts of a first-class modern hostelry." (HSCC.)

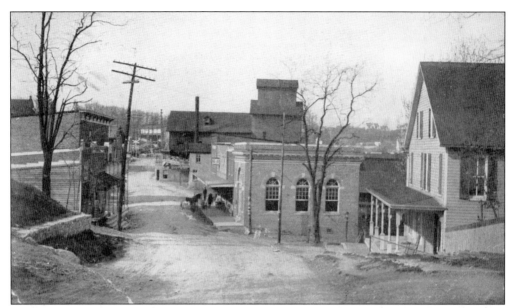

This postcard (above) from 1908 shows Mount Airy's Main Street north of the railroad tracks. At the center is the First National Bank of Mount Airy. It opened in 1904 and constructed this building in 1905. The bank and most of the other buildings in this photograph were destroyed in the 1914 fire. The bank rebuilt on the same site, only to burn in the 1925 fire. In 1926, the company erected an impressive new building (below, in a lithograph postcard) of fireproof materials. (HSCC.)

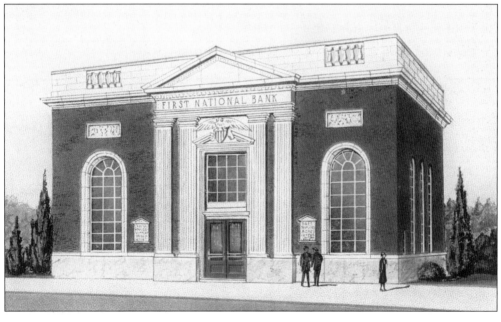

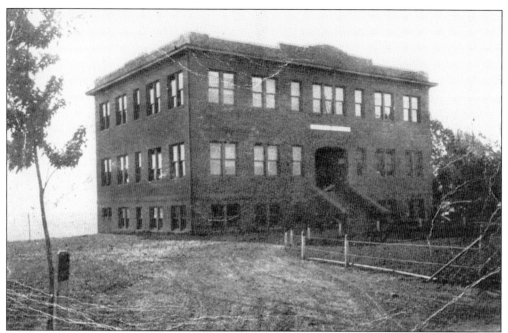

In 1915, Mount Airy constructed an 11-room brick building (above) with facilities for students in all grades. As student enrollment increased, small temporary buildings were added to accommodate the elementary students. The complex was replaced in 1935 with a 20-room building designed for all 11 grades that included an auditorium-gymnasium, cafeteria, and shop. Despite several additions, this building too proved inadequate. In 1957, a separate high school (below) was erected for students in 9th through 12th grades, the 12th year having been added to the system in 1950. This newer building became Mount Airy Middle School in 1967, when the high school students moved to the new South Carroll High School. (Courtesy of the Historical Society of Mount Airy.)

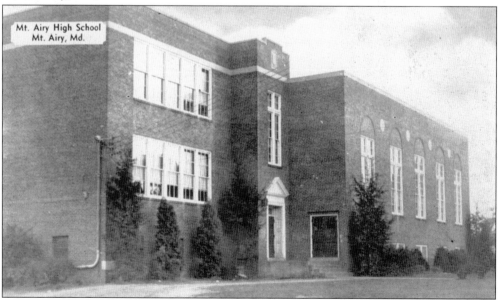

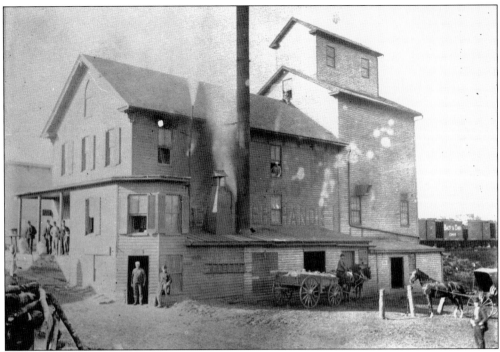

Businesses sprouted along the railroad tracks through Mount Airy. One of the most identifiable structures was this mill, which was constructed in 1890. It remained in use until it was destroyed in the fire of 1914. A new mill was erected on the site. (Courtesy of the Historical Society of Mount Airy.)

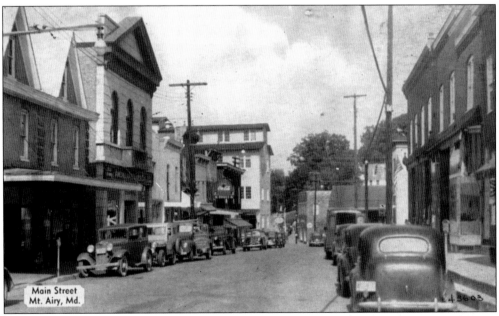

By the time this postcard was produced in the 1930s, downtown Mount Airy had recovered from the series of devastating fires and was thriving. Large masonry structures had replaced the small frame buildings, the street had been paved, and streetlights had been installed. (HSCC.)

Five

NEW WINDSOR

New Windsor nestles between a series of hills in western Carroll County, near the Frederick County line. Isaac Richardson Atlee purchased land where the Monocacy Road and Buffalo Road crossed and in 1797 laid out the 28-lot town seen here. He built an inn at the crossroads to serve travelers and soon added a bathhouse along one of the sulphur springs that ran through the town. Atlee designated the longer street as "Bath" (later Main Street) with "High Street" as the crossroad. Soon people from cities such as Baltimore and Philadelphia were coming to take the waters. Hotels, shops, banks, and other businesses sprouted to serve the town's residents and visitors as the town grew into a prosperous community. The town was known as Sulphur Springs until 1816, when its first post office was established, and it was christened New Windsor. (HSCC.)

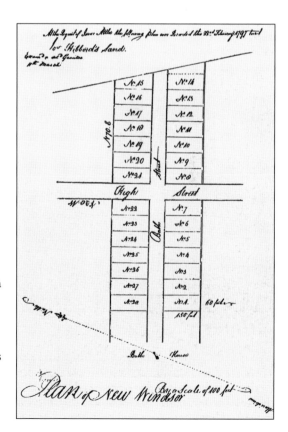

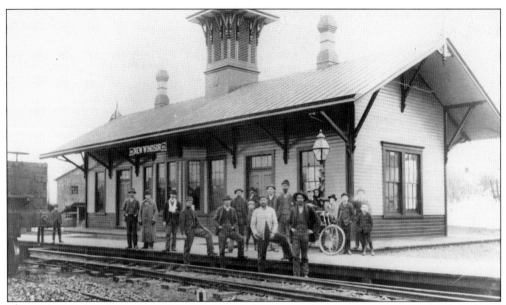

The railroad played a major role in New Windsor's growth. The Western Maryland Railroad reached the town in 1862, allowing farmers and merchants to easily and inexpensively ship their goods beyond Carroll County. In 1896, during construction of Westminster's new passenger station, the old station was dismantled and shipped to New Windsor. This image was taken soon after the station had been reassembled on the south side of Church Street. (Courtesy of New Windsor Heritage Committee.)

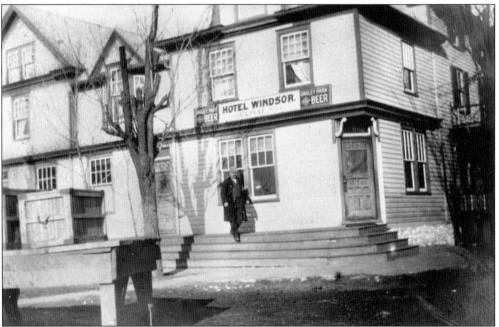

Hotels were built near the passenger station to serve visitors arriving in town. One stood on Church Street, around the corner from the depot. By the time of this c. 1910 photograph, the building had been extended all the way to the corner of Front Street and was known as the Hotel Windsor. (Courtesy of Granville Hibberd.)

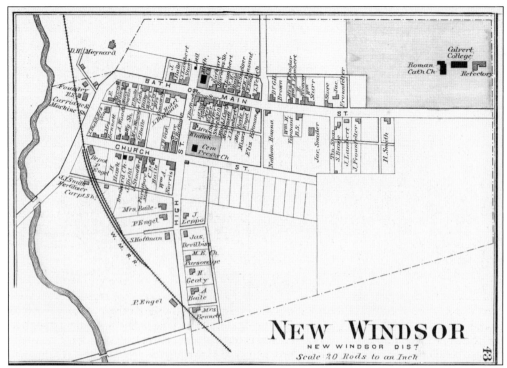

New Windsor's expansion is obvious in the map from the 1877 *Illustrated Atlas of Carroll County* by Lake, Griffing, and Stevenson. Bath Street is now called "Main," Calvert College stands on the hill, High Street has been extended, Church Street has been laid out, houses built, and the Western Maryland Railroad runs through the town. (HSCC.)

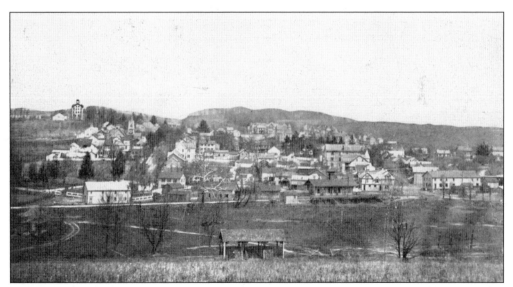

This panoramic view of New Windsor shows the town as it appeared in 1914. "Old Main" at Blue Ridge College stands on the hilltop at the upper left. The Victorian homes on Church Street climb "Quality Hill" in the center of the image. At the foot of Church Street stand the passenger station and warehouses that lined the Western Maryland Railroad tracks. (HSCC.)

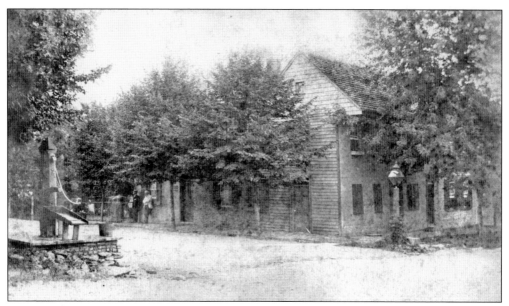

New Windsor's reputation as a tourist destination grew during the 19th century. Visitors arrived by train from the cities, seeking refuge from the summer heat. Isaac Atlee had built a tavern at the corner of Bath and High Streets and constructed his home on the adjacent lot. Eventually the two buildings were connected and a large wing added to the back. In 1864, Louis Dielman, a former professor of music at nearby Calvert College, purchased the inn. This c. 1890 photograph (above) shows the inn and the town water pump. Large gardens surrounded by boxwood hedges, seen in the c. 1870 image below, provided a quiet haven in the middle of town. In 1910, the *Democratic Advocate* called the inn "charmingly artistic" and reported that "artists and literateurs of international reputation are among the patrons." The Dielman family operated the inn until 1927. (Courtesy of the New Windsor Heritage Committee.)

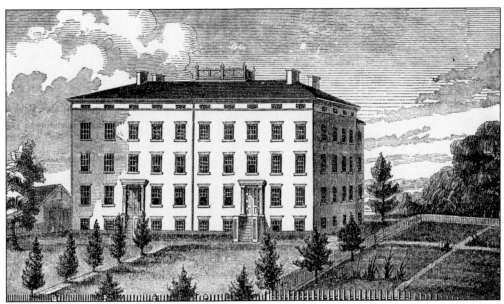

In 1849, Andrew H. Baker bought land on a hill overlooking New Windsor, constructed two buildings, and opened Calvert College the following year. The larger of the buildings (above) would become known as "Old Main." A fire in 1860 destroyed Old Main's mansard roof, which was replaced with a gable roof. Financial difficulties forced the school to close in 1866. The Presbytery of Baltimore purchased the campus and operated New Windsor College from 1872 to 1894. In 1913, the Church of the Brethren acquired the property and moved Blue Ridge College to New Windsor from Union Bridge. The photograph below shows the campus c. 1915. Blue Ridge became a junior college in 1927, and the school closed its doors for good in 1942. In 1944, the Brethren Relief Center opened on the former college campus. (Courtesy of New Windsor Heritage Committee.)

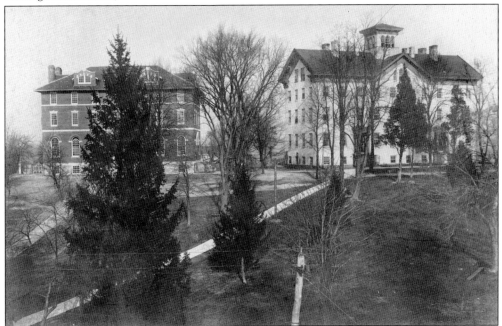

By the late 19th century, New Windsor's merchants and farmers had become wealthy. In 1889, Church Street was extended north past High Street, and some of the town's prosperous residents began to build large new houses along the street. The elegant Victorian houses and wide street, seen in this c. 1910 photograph, led locals to nickname the area "Quality Hill." (HSCC.)

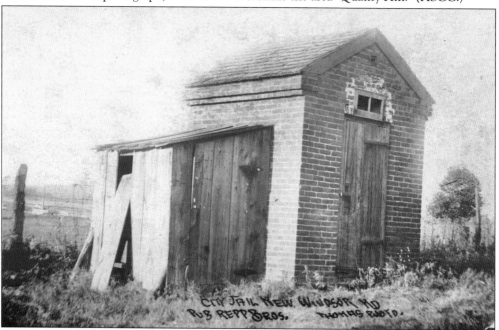

One of New Windsor's unique structures was the jail, seen in this postcard. The structure stood at the northern end of High Street, in the middle of the road between Lambert's store and the Methodist church. Little is known about the jail, but it was probably only used to hold prisoners until they could be transferred to the county jail in Westminster. By the 1920s, the building had disappeared. (HSCC.)

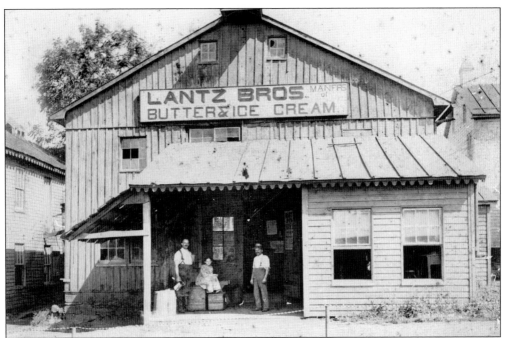

James Lantz and his brother opened a huckster business in New Windsor in the 1860s. They specialized in dairy products and eggs and made deliveries around the region in a large wagon. By the 1880s, James's sons, John and Samuel, were running the business. John (left) and Samuel pose in front of their butter and ice cream plant in this early *c.* 1890 photograph (above). The image below shows the brothers inside the factory. The brothers apparently handled different tasks. In the 1900 federal census, John's occupation was listed as "huckster," while Samuel's was "dairyman." The company was in business through the early 20th century. (Courtesy of New Windsor Heritage Committee.)

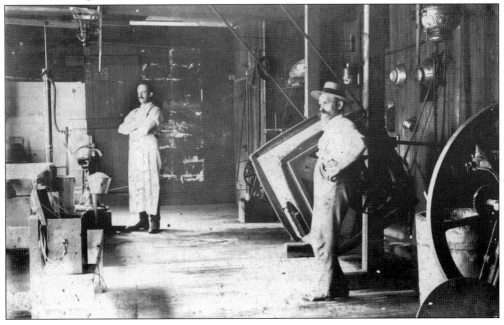

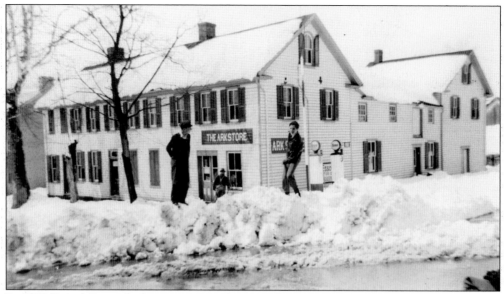

In 1797, Daniel Stoner built a store on Bath Street (later Main Street) across from Atlee's inn. The business passed through several owners before Jesse Lambert purchased it in 1872. By the time of this 1930s photograph, it was known as the Ark Store. Legend says that it was dubbed "the Ark" because it carried two of everything. The store closed in 1942. (Courtesy of New Windsor Heritage Committee.)

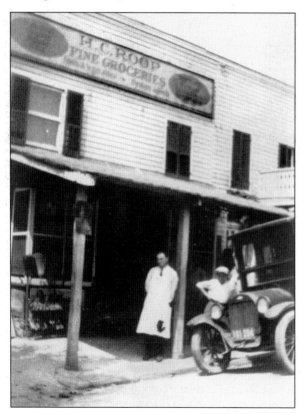

In the late 1890s, Howard Castle Roop opened a store on Main Street. The firm offered free delivery to its customers. Roop posed in front of the store for this 1930s photograph. The front of the delivery van can be seen at right. The business was operated by several generations of the Roop family and eventually moved to a new location on Church Street. (Courtesy of New Windsor Heritage Committee.)

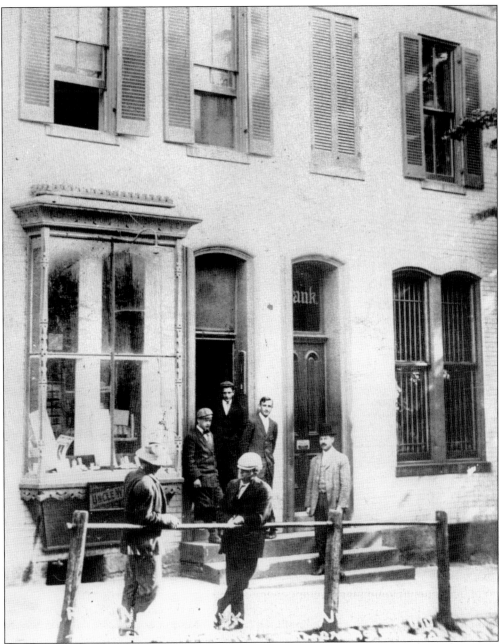

A group of local citizens, headed by Thomas Farquhar Shepherd and Joseph A. Stouffer, established the First National Bank of New Windsor in 1864. It operated out of a small brick building at 205 Main Street. The bank erected a duplex at 209–211 Main Street in 1878. Charles E. Norris's drug store shared the building. Louis Henry Dielman bought the drug store in 1885 and in 1887 added the bay window seen in this photograph. The bank prospered and constructed a large new building with an ornate marble facade at 213 Main Street. The post office moved into the bank's former quarters. Unfortunately the Great Depression hit the business hard, and it closed its doors in October 1931. In 1932, the assets of the First National Bank of New Windsor were sold to the newly formed New Windsor State Bank. (Courtesy of New Windsor Heritage Committee.)

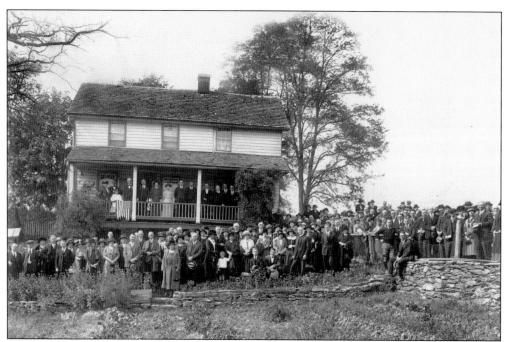

Methodist preacher Robert Strawbridge emigrated from Ireland to Frederick County in the early 1760s. He began preaching in his log home at Sam's Creek, near New Windsor, and soon built a log meetinghouse nearby. Strawbridge's is considered the first Methodist church in America. Nearby the first Methodist class meeting was held in the log cabin of John Evans, one of Strawbridge's first converts. The Strawbridge home passed through several owners and over the years was enlarged and clapboarded (above). The house faded into obscurity until 1915, when a Maryland Methodist historian identified it. The Strawbridge Shrine Association organized in 1934 and acquired the property in 1973. The Evans house (below) still stands though it has been moved to a location on the Strawbridge property. (HSCC.)

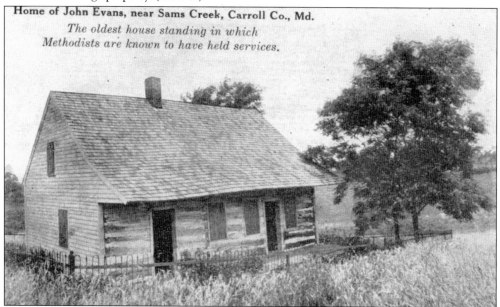

Home of John Evans, near Sams Creek, Carroll Co., Md.

The oldest house standing in which Methodists are known to have held services.

Six

SYKESVILLE

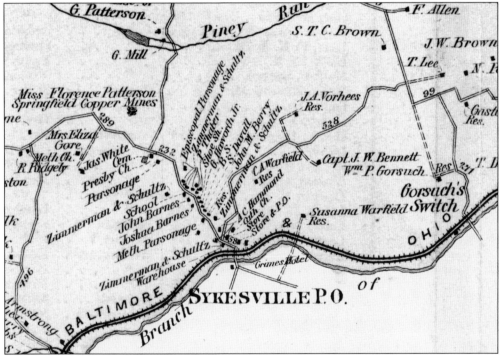

Along the southern border of Carroll County sits Sykesville, on the bank of the Patapsco River. In the early 1820s, a sawmill, gristmill, and two houses stood on the site. James Sykes arrived in 1825 and purchased land on both sides of the river. In 1831, Sykes built a hotel and mill on the north side of the river. He eventually expanded his mill into a cotton factory. A post office was established in the town in 1846. Iron and copper ores were discovered in the area, and by the 1850s, these minerals were being mined, smelted at nearby furnaces, and shipped out on the railroad. A flood in 1868 destroyed the bridge across the Patapsco and much of the town. The bridge and many buildings were reconstructed, and the town flourished throughout the late 19th century. The town incorporated in 1904. This map is from the 1877 *Illustrated Atlas of Carroll County*. (HSCC.)

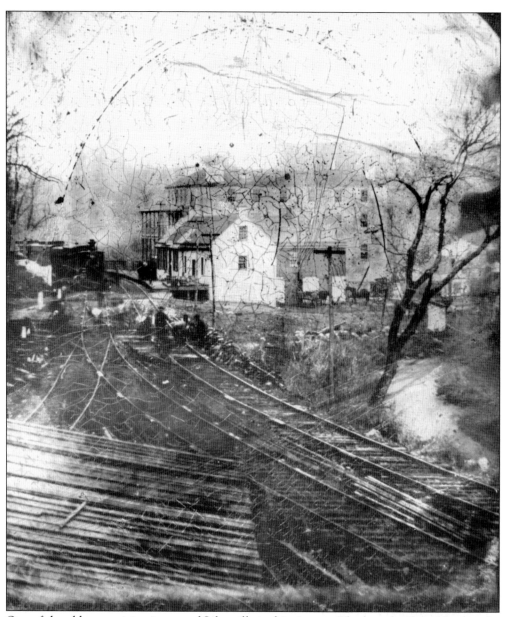

One of the oldest surviving images of Sykesville is this tintype. The large brick building in the background is the Sykes Hotel. The B&O Railroad reached the area that is now Sykesville in 1831. That same year, Sykes erected a hotel adjacent to the B&O Railroad tracks, which are seen in this image. The town quickly became a resort for those escaping Baltimore's summer heat. The smaller white building may have been a railroad station. The hotel was destroyed in the 1868 flood. (Courtesy of the Sykesville Gate House Museum.)

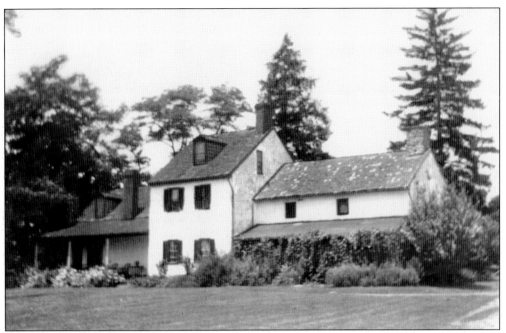

One of the oldest structures in Carroll County is Branton Manor on Liberty Road. John Baptiste Snowden built the earliest part of the structure *c*. 1766 (on the right in this image) on a tract of land called Watson's Trust. His son, Francis, a colonel in the War of 1812, is presumed to have added the tidewater-style section and later the narrow, Federal portion in the center to connect the two ends. (HSCC.)

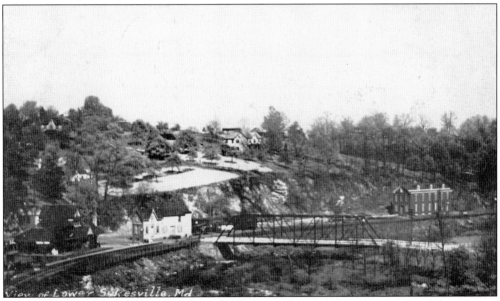

This 1908 view of lower Sykesville shows the Patapsco River in the foreground and the town on the north side. A steel bridge spans the river connecting Carroll and Howard Counties. In the far left foreground is the B&O station designed by E. Francis Baldwin. The 1884 Queen Anne–style structure included separate waiting rooms for men and women and rooms on the upper floor where the stationmaster and his family lived. (HSCC.)

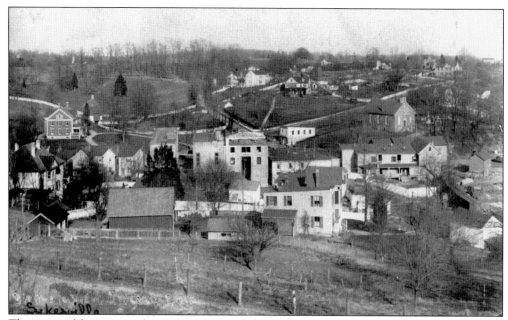

This postcard from 1909, taken from Kalorama Heights, shows the beginnings of modern downtown Sykesville. Main Street runs across the center of the image, and the back of the businesses lining the west side of Main Street can be seen. The McDonald house, now the Town House, stands out at the upper left, and St. Joseph's Church is on the right. (Courtesy of the Sykesville Gate House Museum.)

Businessman Wade H. D. Warfield (1865–1935) had a major influence on the development of downtown Sykesville. He organized several companies, including the Sykesville National Bank, and hired architect J. H. Fowble to design the Arcade and Warfield Buildings on Main Street. Warfield served on the Board of Directors of Springfield State Hospital, and a building there was named in his honor. (Courtesy of the Sykesville Gate House Museum.)

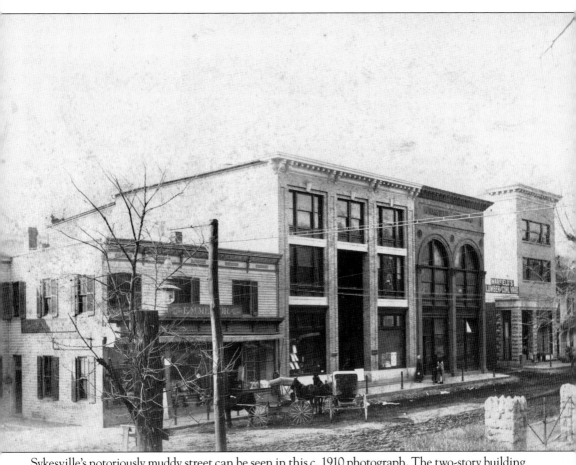

Sykesville's notoriously muddy street can be seen in this *c.* 1910 photograph. The two-story building is the E. M. Mellor general merchandise store. Mellor's store occupied only one room when it opened in 1879 but over the next 20 years grew to over 10,000 square feet. In the center is the Arcade Building, designed and built by Sykesville architect J. H. Fowble in 1907. The structure had a central passage, topped by a pyramid-shaped skylight, from Main Street to Warfield's coal and lumber business in the rear. At right is the 1901 Warfield Building. The Romanesque building with distinctive arched windows was designed by Fowble and constructed as the home of the Sykesville State Bank. In the foreground are the gates to the McDonald house. (Courtesy of the Sykesville Gate House Museum.)

The only person from Carroll County to serve as Maryland's governor was Frank Brown. Born near Sykesville in 1846 on a farm known as Brown's Inheritance, he moved to Baltimore in the 1860s and became a clerk in one of the state's tobacco warehouses a few years later. Brown was elected to the house of delegates in 1875 but served only one term before returning home to manage the family farm after his father's death. In 1880, he became president of the Maryland State Agricultural and Mechanical Society and in 1886 was appointed postmaster of Baltimore. Brown became governor in 1892 following a skillful campaign that touted him as the "Farmer's Friend." His single term in office was marked by his determination to run a government "without frills." Though he remained active in politics, he never ran for office again. Governor Brown died at his home in Baltimore in 1920, having moved to the city after his wife's death in 1895. (HSCC.)

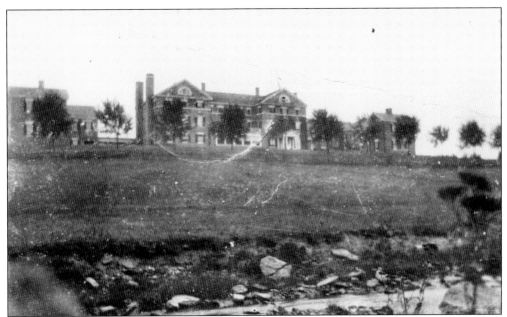

One of the largest land tracts near Sykesville was Springfield Estate, the country home of Baltimore merchant William Patterson. George Patterson inherited the property in 1824 and the following year sold a portion to James Sykes. Frank Brown inherited the rest of the estate in the 1890s. In 1894, the state legislature decided to erect a second "Hospital for the Insane of Maryland." The planning committee selected Springfield as the appropriate site, and the state bought the property from Governor Brown. The first patients arrived in July 1896 and were housed in renovated farm houses while the hospital buildings were constructed. The hospital complex grew over the decades, and the patient population peaked in the 1960s at over 3,300. The postcard above shows the hospital in 1911. Below is a later aerial view showing the facility's growth. (HSCC.)

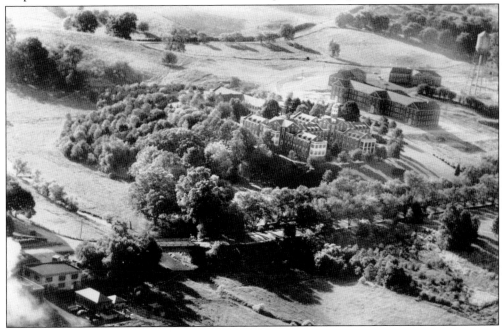

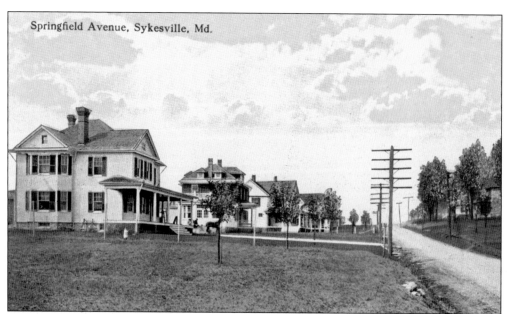

Frank Brown laid out Springfield Avenue the 1880s as a route from the B&O station and downtown Sykesville to summer rental cottages he constructed on part of his large estate. The Brown Cottages were small, boxy structures with flat roofs. Soon large private homes such as the ones in this postcard were erected. This view is looking north up the avenue. (Courtesy of the Sykesville Gate House Museum.)

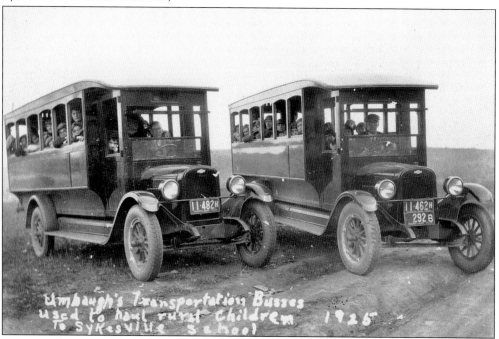

In the 19th century, most children in Carroll County lived close enough to their schools that they walked to and from their homes. As schools became more centralized, transportation had to be provided for students. Buses from Umbaugh's Transportation carried children to school in Sykesville in the 1920s. (HSCC.)

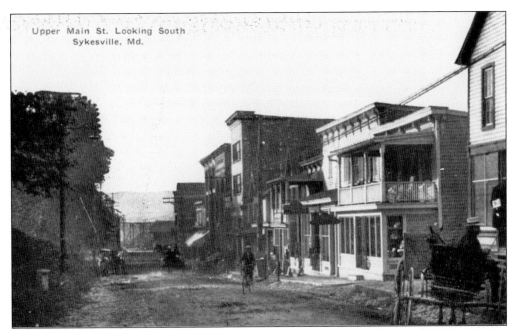

This *c.* 1914 postcard looks south along upper Main Street. The two-story porch on the building in the foreground was added around 1907. The Harris Department Store occupied the structure for many years. The Warfield Building can be seen near the middle of the block. (Courtesy of the Sykesville Gate House Museum.)

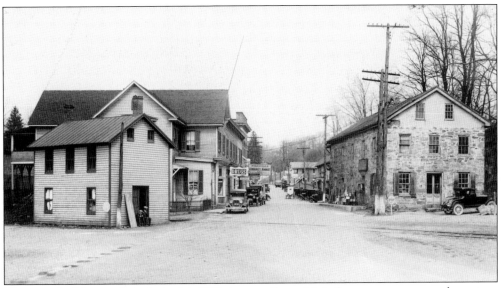

The stone building at the right in this 1930s image of lower Main Street was constructed as a store in 1865 and was one of the few structures to survive the flood of 1868. In 1939, the Sykesville Volunteer Fire Department renovated it for use as a firehouse. When the fire department moved to new quarters 10 years later, St. Barnabas Episcopal Church purchased the building. (Courtesy of the Sykesville Gate House Museum.)

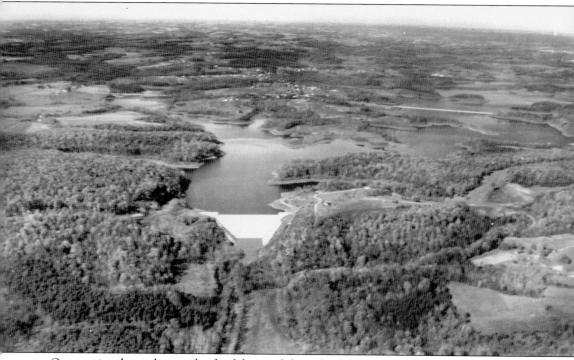

On a peninsula on the west bank of the north branch of the Patapsco River perched the village of Oakland Mill. The Bennett family had utilized the waterpower to establish a mill on the site in the early 19th century. By the end of the century, the company was known as the Oakland Manufacturing Company of Carroll County, and a thriving community had grown up around the mill. The business became the Melville Woolen Company in 1915 and produced fine woolen fabrics. In 1931, the Maryland legislature decided to "convert the entire valley or basin of the Patapsco River . . . into a lake or watershed" to provide water for the city of Baltimore. Work was delayed, but in the 1950s, the mill closed, the contents of the plant were sold at auction, and the town's residents were forced to find new homes. The massive construction project created a 160-foot-high dam, which encloses the 43-million-gallon Liberty Reservoir, and a series of bridges to carry Liberty Road over the reservoir. This aerial photograph shows the completed dam and its watershed. (HSCC.)

Seven

TANEYTOWN

Taneytown, in the northwest corner of the county, traces its founding to 1754. On May 22 of that year, Edward Diggs and his son-in-law, Raphael Taney, patented a 7,900-acre tract of land. Taney laid out lots and began selling property in "Taney Town." By end of the 18th century, there was a tavern on each corner of the town square. George Washington, who stayed at the Adam Good Tavern in 1791, noted the town was "a small place with only the street through which the road passes built on." The coming of the Frederick and Pennsylvania Line railroad, seen on this 1877 map from the *Illustrated Atlas of Carroll County*, led to an economic boom with factories, warehouses, banks, and fashionable Victorian houses constructed around the town. The city was incorporated in 1884. (HSCC.)

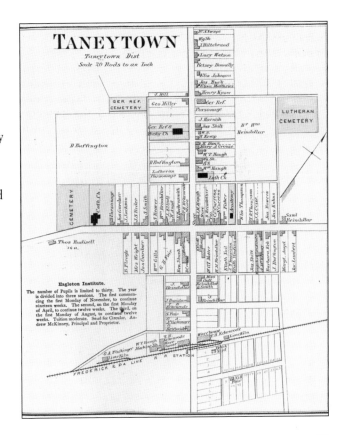

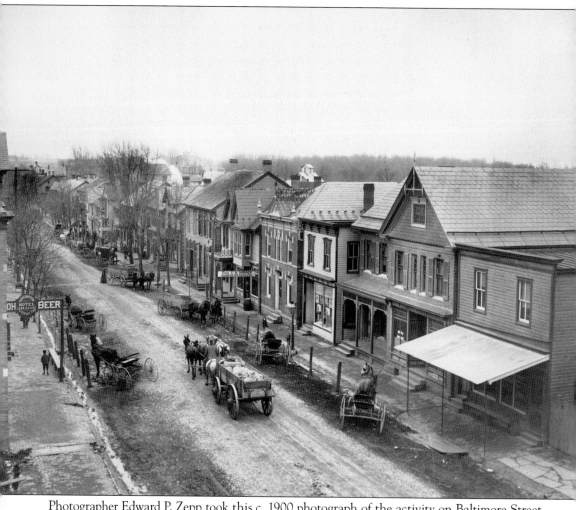

Photographer Edward P. Zepp took this *c.* 1900 photograph of the activity on Baltimore Street from his studio on the second floor of the Central Hotel at the northeast corner of East Baltimore and York Streets. The first building on that site was a log inn constructed in 1767. By the 1860s, the log structure had been encased in brick, and David Mehring built a new brick building on the site in 1902. To the left can be seen the Buffington Hotel, John D. Kane, proprietor. Across the street from left to right are Charles E. H. Shriner, Harness and Saddledry; the Taneytown Saving Bank; Robert S. McKinney, Druggist; and the post office. Ed Zepp worked in Taneytown for many years and produced the most famous images of the town, several of which appear in this book. (HSCC.)

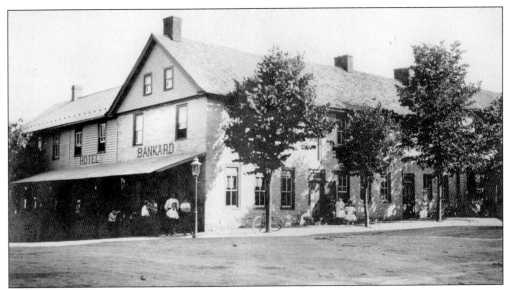

The stone hotel on Frederick Street is believed to be the oldest extant building in Taneytown. Originally the building, constructed in 1760, extended for over 400 feet with stables behind. The hotel operated under various names over the years, including Elliot House and Hotel Bankard. Much of the building was demolished in 1921 for construction of Hesson's second department store. (HSCC.)

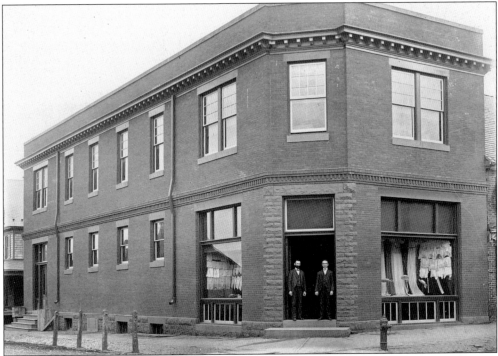

D. J. Hesson opened a department store on the northwest corner of the square in November 1903. Hesson and his son, Clyde, posed in the doorway for this photograph. The store expanded in 1921 and remained in business until 1942. Many businesses have occupied the building since Hesson's closed, including the Earle Theater in the 1940s. (HSCC.)

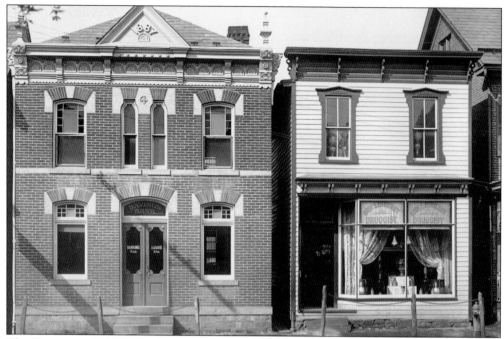

The Taneytown Savings Bank (at left) was organized in 1887, with Amos Duttera as president and Henry Galt as treasurer. Next door stood the druggist's shop opened by Robert S. McKinney. McKinney opened his store in 1890 and remodeled only five years later, installing the latest equipment for compounding drugs. McKinney ran the business until his death in 1946. (HSCC.)

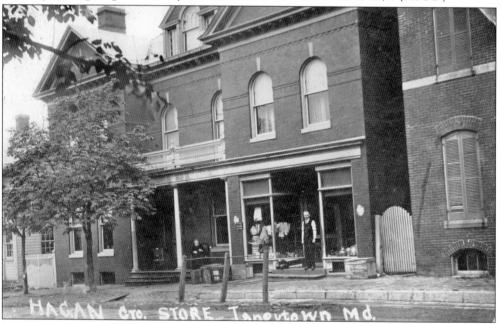

Norman B. Hagan opened a grocery and confectionery shop in the 1890s and constructed a large brick building on Frederick Street, on the site of the old Adam Good Tavern. The Classical Revival–style building also served as a home for Hagan and his wife, seen in this early-20th-century photograph. (HSCC.)

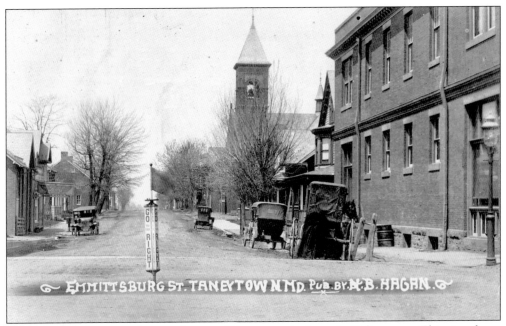

Hagan produced a series of postcard views of Taneytown in the early 20th century. This view shows Emmittsburg Street, now known as West Baltimore Street. An early traffic control device stands in the middle of the intersection—a four-sided sign warning drivers to "Go to the Right." (HSCC.)

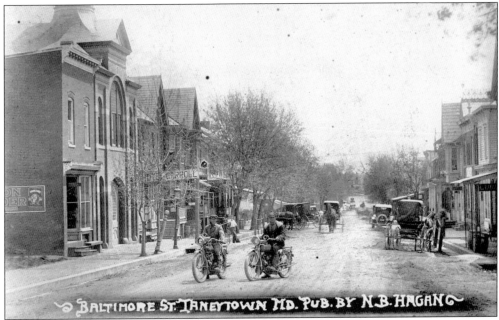

Another Hagan postcard shows East Baltimore Street, c. 1920. On the left side of the street is the 1903 firehouse, which had town offices on the second floor. Next to the firehouse stands the Hotel Carroll. At this time, the popular forms of transportation are changing, and a mix of vehicles—buggies, automobiles, and motorcycles—share the dirt street. (HSCC.)

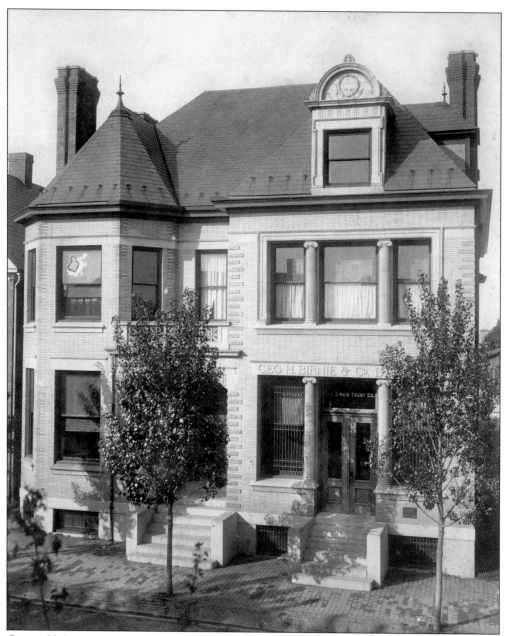

George H. Birnie, E. E. Reindollar, and Dr. G. T. Motter founded the banking firm of George H. Birnie and Company in 1884. The firm soon became known as the Birnie Trust Company. The bank's headquarters at 103–105 East Baltimore Street, erected in 1899, was a unique blend of Victorian and Classical Revival architecture. The left side of the building was Birnie's residence, and the right side housed the bank. The bank remodeled the building several times over the years. Birnie Trust Company continued banking operations until 1966, when it merged with the First National Bank of Taneytown to become the Taneytown Bank and Trust Company. (HSCC.)

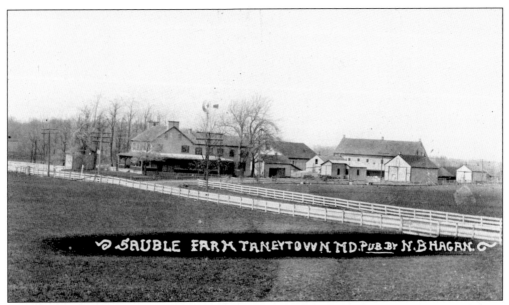

Around 1796, the Crapster family built Locust Grove at the western edge of Taneytown, operating a stagecoach inn and tavern there. By the 1860s, Dr. Samuel Swope owned the property. When the Union Army of the Potomac's 2nd Corps arrived in Taneytown on July 1, 1863, they camped on Swope's farm. George and Irene Sauble purchased the farm in 1912, and a few years later opened a restaurant. Sauble's Inn operated until 1943. (HSCC.)

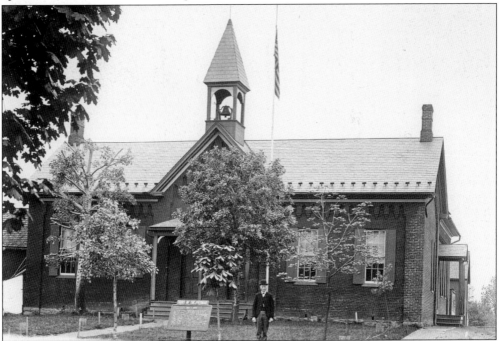

In the early 19th century, Taneytown boasted a number of private schools. By 1870, Taneytown's first public school had been established in a fine, brick building on York Street that accommodated nearly 100 students. Principal Levi D. Reid posed in front of the school for this photograph by Edward Zepp. The school was remodeled over the years before closing in 1925. (HSCC.)

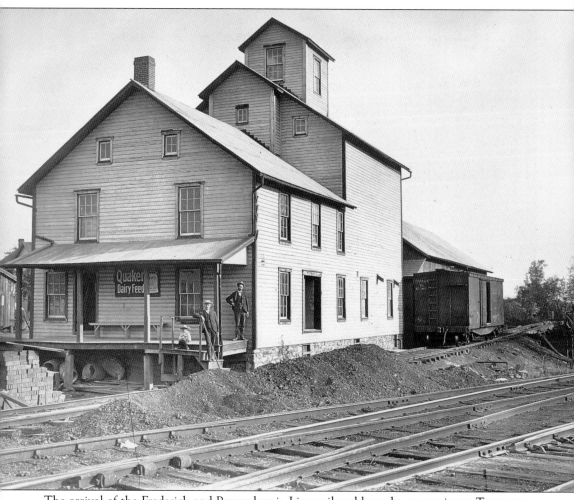

The arrival of the Frederick and Pennsylvania Line railroad brought prosperity to Taneytown. Businesses sprang up alongside the tracks to take advantage of the easy, inexpensive means of transportation. The grain elevator in this photograph was built in 1899 by the Farmer's Warehouse Company. The original board of directors included Samuel Stover, Edward Kemper, G. W. Baumgardner, Joseph Roelky, and Calvin Fringer. Later it was leased to the Taneytown Elevator Company, which eventually became the Taneytown Grain and Supply Company. In this photograph Laverne Zepp sits on the steps while Joseph Roelky and Frank Crouse stand. (HSCC.)

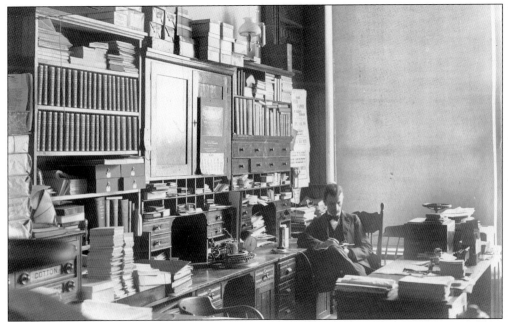

The first issue of the *Carroll Record* newspaper appeared on July 7, 1894. The company purchased the equipment of the defunct Westminster *Carrolltonian*, which had ceased operations the previous year. Preston B. Englar, seen here at his desk in the newspaper office, was a founder of the newspaper and served as editor until his death in 1945. The last issue of the paper appeared in 1971. (HSCC.)

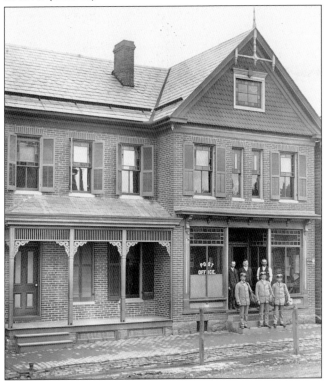

Englar's building at 16 East Baltimore Street was constructed in 1886 as his home and store. It became the post office following his appointment as postmaster by Pres. Benjamin Harrison in the early 1890s. Pictured in this 1905 photograph, from left to right, are (first row) Harry Baumgardner, Charles Baumgardner, and Kurg Eyler (mail carriers); (second row) Stanley Reaver (postmaster), Arthur Combs (assistant postmaster), and John Yingling (mail carrier). (HSCC.)

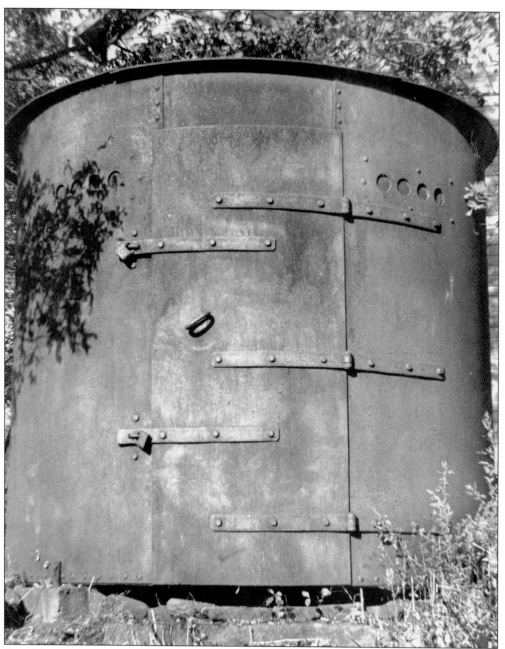

Probably the most unusual building in town was the city jail. Constructed of steel plates, and weighing about two tons, the jail housed suspects picked up at odd hours when it was not convenient to take them immediately to the county jail in Westminster. Prisoners were never held for long periods of time or received sentences that were to be served in the "can." The jail disappeared in the early 1940s when it was donated to a scrap-metal collection drive during World War II. (HSCC.)

Eight

UNION BRIDGE

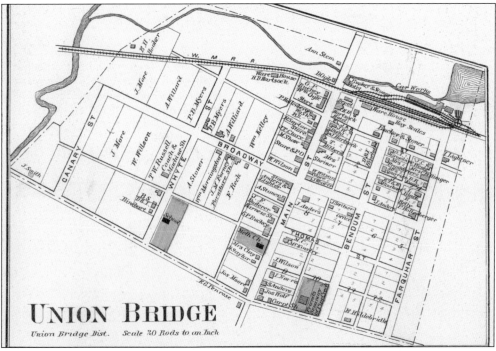

UNION BRIDGE

Union Bridge Dist. Scale 70 Rods to an Inch

Union Bridge sits near the western boundary of Carroll County, along the banks of Pipe Creek. John Tredane purchased the first land in the area in 1729, and Allen Farquhar followed in 1734. The next year, Farquhar gave his son, William, 200 acres that included what would become the western and northern parts of town. William was a tailor and made a good living making buckskin breeches. He invested his profits in land and by 1768 owned 2,000 acres that included all the land that is now Union Bridge. The community was known originally as Pipe Creek Settlement and later as Buttersburg, after the dairy products sold in a local store. The town was designated Union Bridge by the postal service in 1820 in honor of the bridge over Pipe Creek that joins the sections of town. Union Bridge grew steadily throughout the 19th century and incorporated in 1872. This map is from the 1877 *Illustrated Atlas of Carroll County*. (HSCC.)

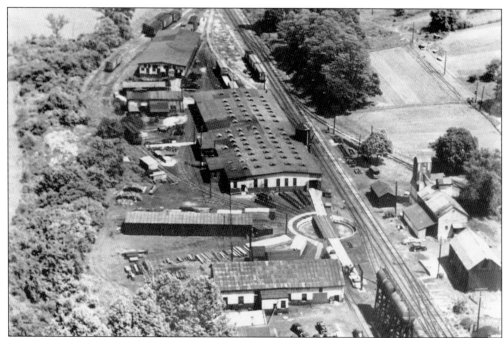

The coming of the railroad played an important role in Union Bridge's development and for many years the survival of one depended on the other. The Western Maryland Railroad reached Union Bridge in 1862, and for the next 10 years the town was the terminus of the rail line. The Western Maryland constructed large workshops, a turntable (above, *c.* 1920), and housing for its workers. By the early 20th century, the railroad employed 300 of the town's 1,000 residents. Some of the workers posed for this photograph in 1910 (below). (HSCC.)

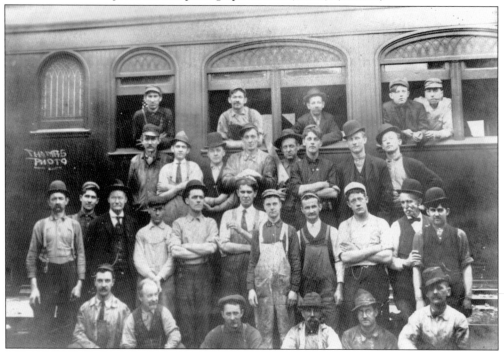

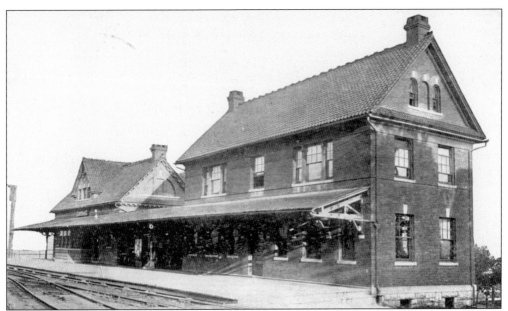

The Western Maryland Railroad constructed a passenger station in Union Bridge in 1875. This was apparently a simple frame building. In 1902, a new station, designed by Baltimore architect Jackson Gott, was constructed. It was of brick, trimmed with limestone, and featured a red tile roof. There were separate waiting rooms for men and women. The last passenger train stopped in Union Bridge in 1957. (Courtesy of Angelo Monteleone.)

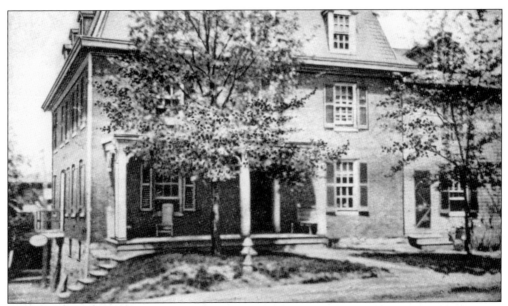

Union Bridge had several hotels conveniently located near the passenger station. This postcard, postmarked 1915, shows the Western Maryland Hotel, which stood across Main Street on the corner with Elger Street. The building still stands but looks very different today. (Courtesy of Angelo Monteleone.)

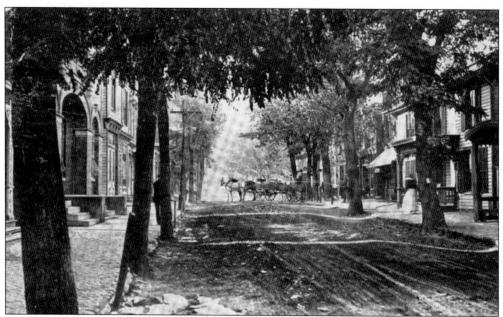

In March 1874, the town council resolved that since "the streets of Union Bridge have heretofore had no legal name, . . . the principal thoroughfare through the said town, being the Liberty and Pipe Creek turnpike road, be called 'Main Street.'" The council went on to name all the other streets in town. The postcard above shows Main Street in 1911. By the time of the *c.* 1950 photograph below, Main Street had changed significantly. The street has been paved and streetlights installed. Modern signs dominate the streetscape, but many of the old buildings remain. (Top image: HSCC; bottom image courtesy of Angelo Monteleone.)

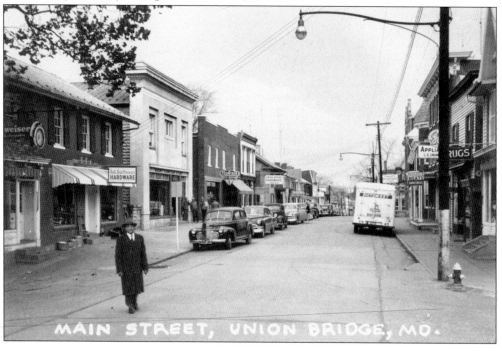

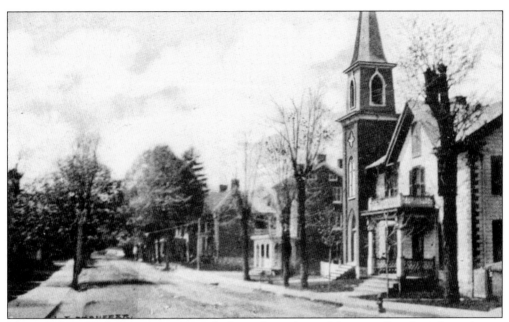

Many of Union Bridge's streets are named after early residents of the town. Broadway, however, got its name because it is very wide—a broad way. This early-20th-century postcard looks west along Broadway with the Reformed church in the foreground. (Courtesy of Angelo Monteleone.)

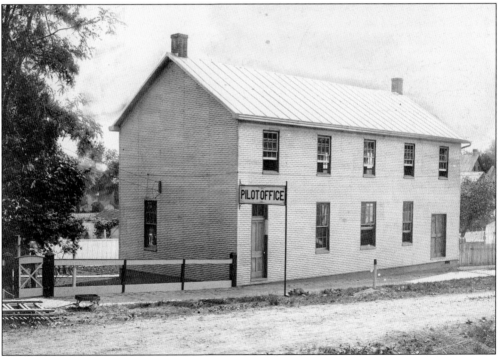

The first issue of the Union Bridge *Pilot* appeared on October 27, 1899, with J. Hamilton Repp as editor and proprietor. The newspaper changed hands several times over the years with J. Ross Galt, Oliver J. Stonesifer, and M. H. Rakestraw serving as editor at various times. The *Carroll County Times* purchased the *Pilot* in 1969 and published it as a special section until 1972. (HSCC.)

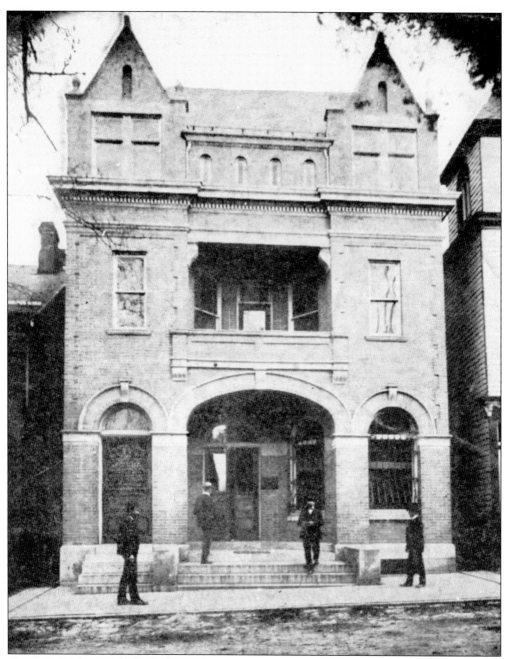

George P. Buckey established a private bank in Union Bridge in the early 1880s. When he retired in 1899, the assets of his business were assumed by a new company. The Union Bridge Banking and Trust Company incorporated on November 15, 1899. Among the founders were Jacob Stoner, Nathan Engler, Silas Senseney, George Buckey, and George W. Albaugh. The bank constructed an impressive building of buff brick at 18 North Main Street. The building was expanded in 1939. In 1957, the company merged with a bank from Frederick to form the Farmers and Mechanics National Bank of Union Bridge. Though the interior has been greatly altered, the exterior remains largely unchanged, and the building is still a bank. (HSCC.)

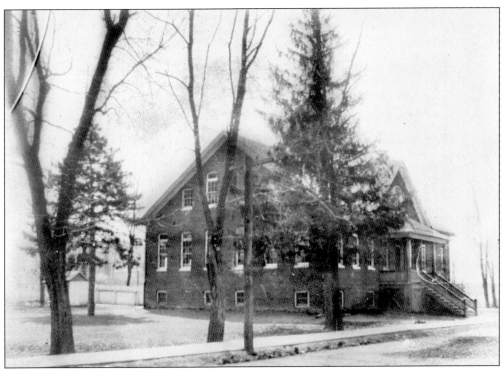

By the 1860s, a two-room school stood on White Street. The old school was replaced in the 1870s by the brick structure seen here. There were four classrooms with a shop and domestic science (home economics) room in the basement. This school remained in use until Elmer Wolfe High School opened in 1931. The old school was demolished, and the carnival grounds now occupy the site. (HSCC.)

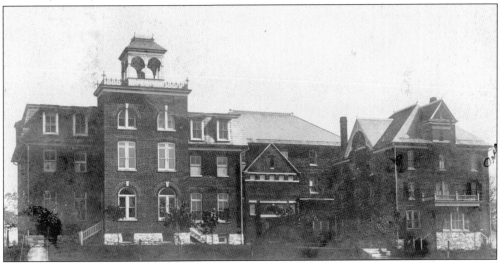

The Maryland Collegiate Institute erected two large buildings on the south edge of Union Bridge. In this photograph, MacKalean Hall (administrative offices) is to the left, and Adelphian Hall (library and chapel) is to the right. In 1912, the campus closed when the school merged with New Windsor College. The Tidewater Portland Cement Company purchased the buildings and used Adelphian Hall as its offices for many years. (HSCC.)

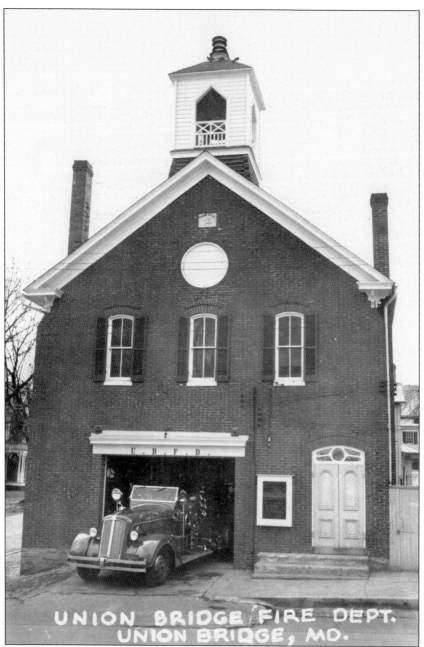

UNION BRIDGE FIRE DEPT.
UNION BRIDGE, MD.

In 1868, fire swept through the buildings at the Western Maryland Railroad yard. In response, the town purchased two extension ladders, two hook ladders, and 15 rubber fire buckets. In the 1880s, it acquired a chemical engine, which was kept in a stable. Work began on a combination town hall and firehouse in 1884, and the building was completed the following year. However, the Union Bridge Fire Company was not organized until March 1887. The town then provided a hook and ladder wagon and two hose reels. A tower and bell were added to the building in 1891. Beginning in the 1920s, the department purchased several motorized vehicles and outgrew their facility. The department moved to a new firehouse at Locust and White Streets in 1967. The old building was sold at that time and is now a private residence. (Courtesy of Angelo Monteleone.)

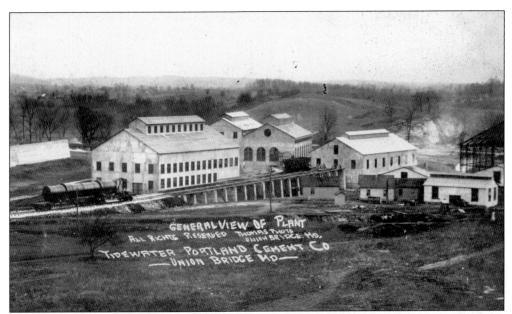

In 1909, a group of businessmen established the Tidewater Portland Cement Company to take advantage of the limestone deposits near Union Bridge. The factory opened in 1910 on 200 acres south of the town. The complex included mills for crushing and grinding stone, kilns, a dynamo to power the works, storage sheds, and railroad tracks for moving materials. This early image (above) shows the operation in 1911. Limestone was quarried south of the plant, near Sam's Creek. The original quarry (below) relied on manpower, horses, and wagons to remove the stone and haul it to the plant. There the stone was turned into gray Portland cement, white Portland cement, and hydrated lime. Lehigh Portland Cement Company purchased the operation in 1925. The plant is still in operation, having been modernized and enlarged several times. (Courtesy of Angelo Monteleone.)

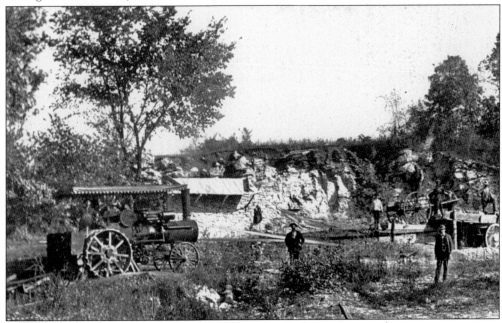

Sculptor William Henry Rinehart was born September 13, 1825, on a farm near Union Bridge. There his father put him to work at a marble quarry that had been opened on the property. He polished and lettered blocks for tombstones, windowsills, doorsills and other items to be sold throughout the community. In 1846, he headed to Baltimore, where he became an apprentice to Baughman and Bevan, the largest stone-cutting firm in the city. Rinehart left to study in Florence, Italy, in 1855. He moved to Rome, Italy, in 1858 and maintained his principal studio there for the rest of his life. Though Rinehart died of tuberculosis in 1874 at only 49 years of age, his works live on, including the bronze doors for the U.S. Capitol, a bronze statue of Justice Roger Brooke Taney in Annapolis, 100 portrait busts, and over 30 pieces of statuary. (HSCC.)

Nine

AROUND THE COUNTY

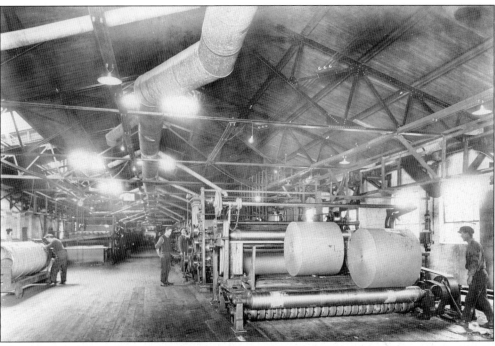

The previous chapters have looked at the eight incorporated cities, the largest communities in Carroll County. Yet most of the county's citizens live outside those cities—in small crossroad communities scattered around the county. Many of these small communities grew up along a transportation route such as a river or railroad. Others centered around a business or factory. The town of Asbestos, just east of Westminster, is a good example of one of these communities. The Baltimore Roofing and Asbestos Manufacturing Company (above) built a large factory there in 1913. The company used asbestos-cement (a composite of Portland cement reinforced with asbestos fibers) to produce construction materials such as synthetic roof and wall shingles, corrugated wall and roof panels, and decorative wall and ceiling moldings. The factory closed in 1920. (HSCC.)

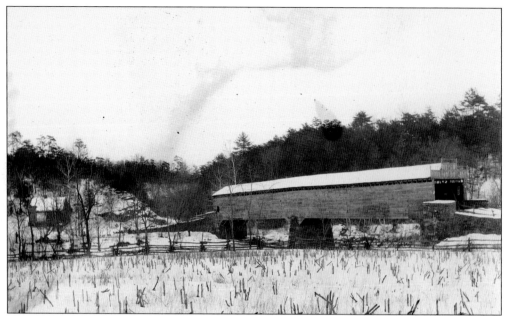

Though covered bridges were not common in Carroll County, there were a few. This example spanned the Monocacy River at Bridgeport. The bridge was constructed in 1849 and remained in use until 1932. Photographer Ed Zepp of Taneytown captured this image of the bridge in the early 20th century. (HSCC.)

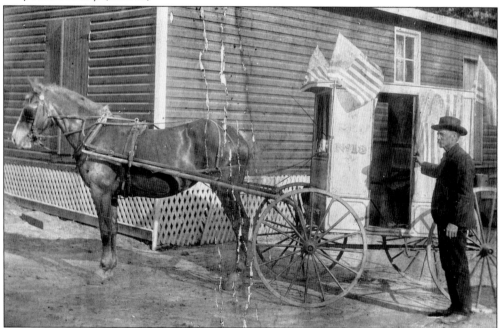

The community of Haight, near where Oakland Mills Road and Mineral Hill Road meet, consisted of a store, post office, and a few houses. In the 1880s, the Haight family purchased the store and opened the post office. The post office closed in 1899 with the beginning of the rural free delivery system. Philetus Haight (seen here) became a rural carrier and covered over 19 miles delivering mail to communities including Haight, Eldersburg, and Sykesville. (HSCC.)

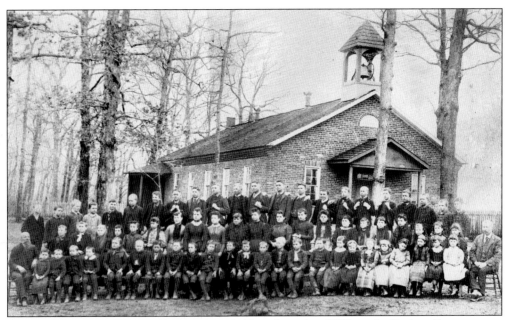

Principal Simon P. Weaver (front row, at left) and teacher William L. Corbin (front row, at right) pose with their students in this 1888 image of the Frizellburg Academy. The brick school on Uniontown Road opened in 1869, replacing an earlier wooden structure on Pleasant Valley Road. Frizellburg Academy was typical of the one-room schoolhouses that could be found across Carroll County, serving the children of the smaller communities. (HSCC.)

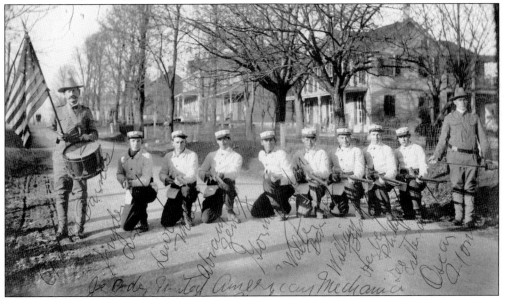

Originally named Mechanicsville because of the carpenter, wheelwright, and blacksmith whose shops were located there, the town now known as Gamber was renamed in honor of its postmaster, William S. Gamber. This 1912 image shows the drill team of the Junior Order of United American Mechanics. From left to right are Charles H. Barnes (flag bearer), Arnold Snyder, Lewis Miller, Abram Zentz, Jordan Gorman, Walter Barnes, William Bush, Herbert Phillips, Leo ?, and Oscar Monroe. (HSCC.)

John Ross Key built his home, Terra Rubra, near Keymar, on the eastern edge of Frederick County (now Carroll County) in 1770. It was there that his son, Francis Scott Key, was born on August 1, 1779. The original house was destroyed in the 1850s and a new structure built on the site, but the original springhouse, seen in this late-19th-century photograph, remained. (HSCC.)

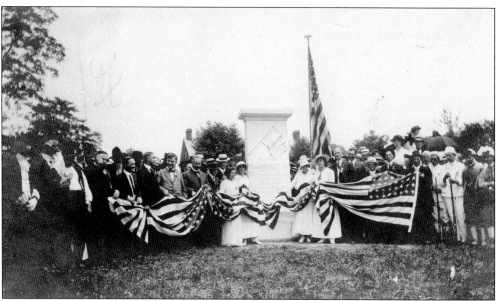

A memorial to Francis Scott Key was constructed at Terra Rubra and dedicated on June 12, 1915. The monument was a gift from the Patriotic Order Sons of America and Carroll County schoolchildren who donated money for its construction. (HSCC.)

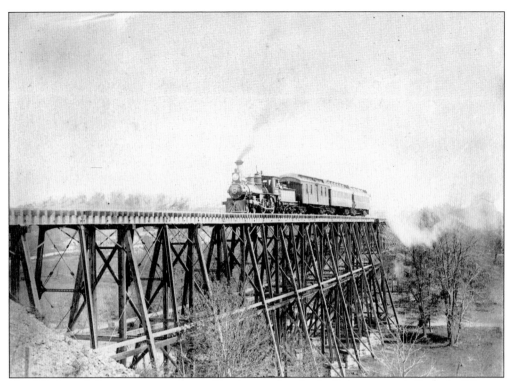

By 1877, Carroll County was crisscrossed by three railroads: the Baltimore and Ohio, the Western Maryland, and the Frederick and Pennsylvania Line. In this *c.* 1890 image, a locomotive with two passenger cars crosses the Pennsylvania Railroad Bridge over Big Pipe Creek at Keymar. A hurricane destroyed the bridge in 1972. (HSCC.)

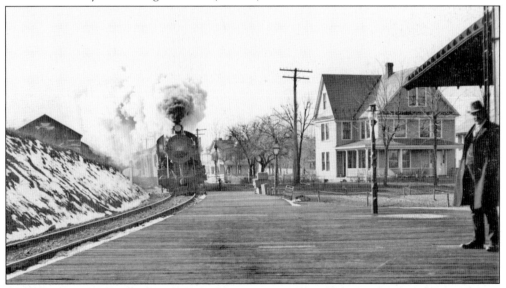

The Western Maryland Railroad reached Keymar in 1867, with the Frederick and Pennsylvania Line following in 1872. A small but thriving community grew up around the railroad crossing. In this image from January 1912, a train pulls into the Keymar station while E. O. Cash waits on the platform for its arrival. (HSCC.)

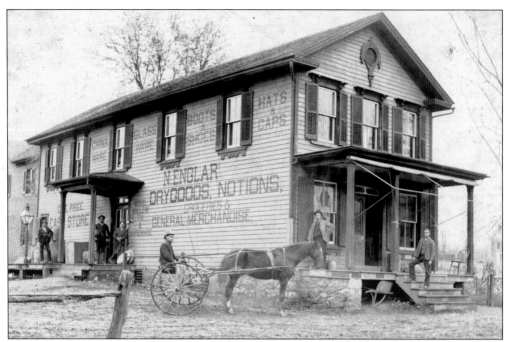

Nathan Englar opened a store at Linwood in the 1870s. He sold dry goods, tablewares, clothing, groceries, and general merchandise. Englar (wearing a light coat and derby hat) poses on the porch for this late 1880s image (above). The store provided Englar with the means to build a new home. The large brick house with distinctive mansard roof took two years to build, from 1884 to 1886. Englar and his son, Roy, posed in front of their new home for this image (below). Since Englar is wearing the same clothing as in the photograph of his store and both images were taken by the same photographer, it is likely that these two photographs were taken the same day. (HSCC.)

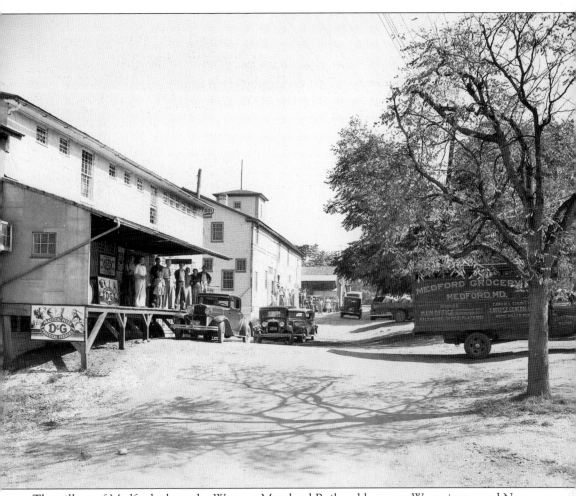

The village of Medford, along the Western Maryland Railroad between Westminster and New Windsor, was a small community with a railroad station, post office, and a very special store. The Medford Grocery, housed in a group of barn-like buildings, offered an amazing selection of goods including bread, underwear, dishes, potatoes, wallpaper, blankets, house paint, dynamite, beans, bird seed, gasoline, and almost anything else the customer could want. The store originally marketed to Carroll County residents but by the 1930s was advertising in 15 newspapers across the state. The genius behind the store was J. David Baile, who not only operated the store but managed a 1,000-acre farm, served in the state senate, and was the founding president of the Historical Society of Carroll County. In 1937, Medford Grocery generated over $200,000 in sales. Unfortunately the business closed after Baile's death in 1944, and little remains on the site today. (HSCC.)

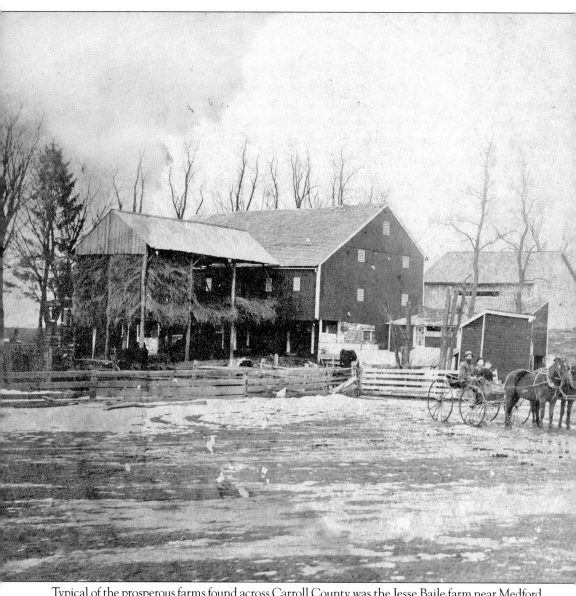

Typical of the prosperous farms found across Carroll County was the Jesse Baile farm near Medford. The farm was located near where the railroad tracks crossed the New Windsor Road. In this *c.* 1900 photograph, from left to right, are (in buggy) Jesse, Chester A., and Roland P. Baile; (with

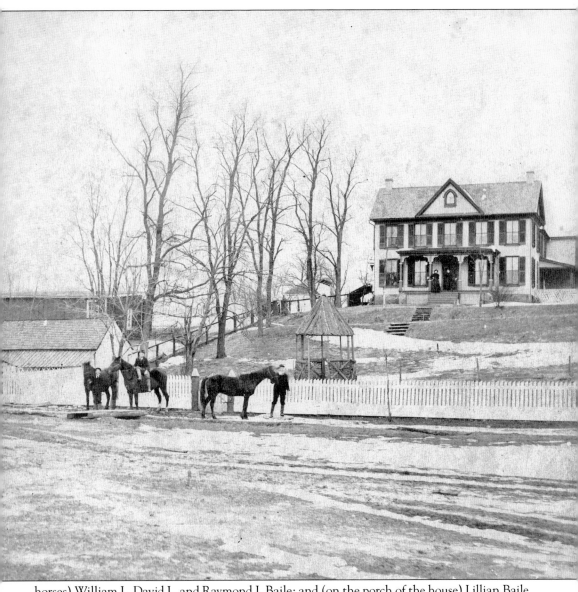

horses) William J., David J., and Raymond J. Baile; and (on the porch of the house) Lillian Baile (Englar) and Louise Baile (Taylor). (HSCC.)

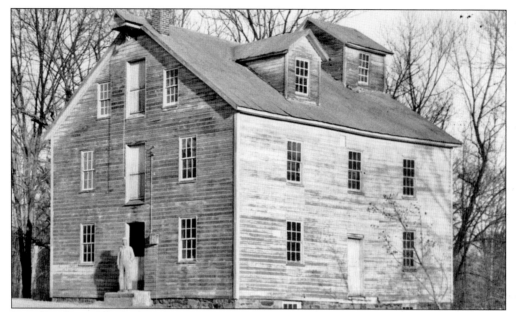

David Buffington built the original mill along Big Pipe Creek at Middleburg. In 1887, after fire destroyed the original building, Henry Menges erected a frame building for use as a gristmill and sawmill. The Crouse family purchased the mill two years later. Crouse Mill (also known as the Middleburg Roller Mill) operated until 1978. (HSCC.)

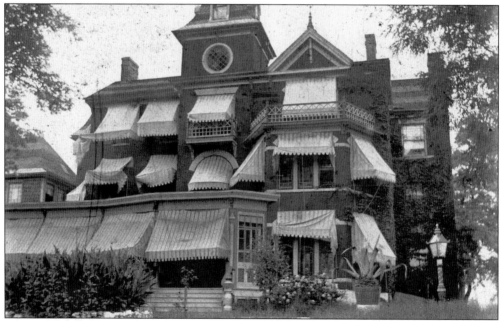

Also in Middleburg was Bowling Brook, home of Robert Wyndham Walden, the most famous horse trainer of his day. Walden moved his family from New York in 1878. He built stables that could house 200 horses at a time and an enclosed circular track that allowed his horses to train year-round. Walden trained seven Preakness winners, including five straight from 1878 to 1882. The track is gone, but Bowling Brook still stands, though its third floor has been removed. (HSCC.)

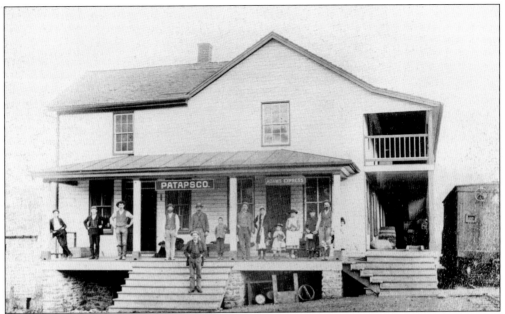

In 1859, Jesse Brown purchased land and opened a mill in the bottom where the East and West Branches of the Patapsco River meet to form the North Branch. In 1852, the area became known as Carrollton, and the name changed to Patapsco in 1878. Trains on the Western Maryland Railroad stopped here to take on wood and water. The general store, seen here, stored grain waiting to be shipped by rail. (HSCC.)

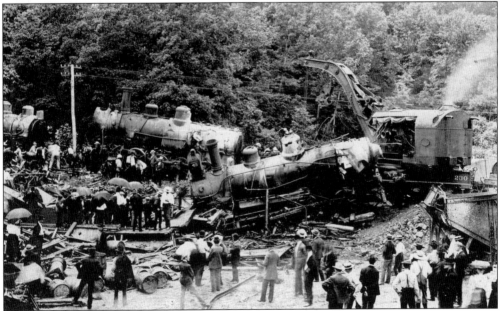

The worst railroad accident in Carroll County history occurred on the Western Maryland Railroad on June 19, 1905, when the passenger express from Baltimore collided with a freight train on a sharp curve near Patapsco. The express had 80 passengers on board along with Western Maryland workers returning home. The 26 men killed in the crash were all railroad employees riding in the baggage and smoking cars; none of the other passengers was seriously injured. (HSCC.)

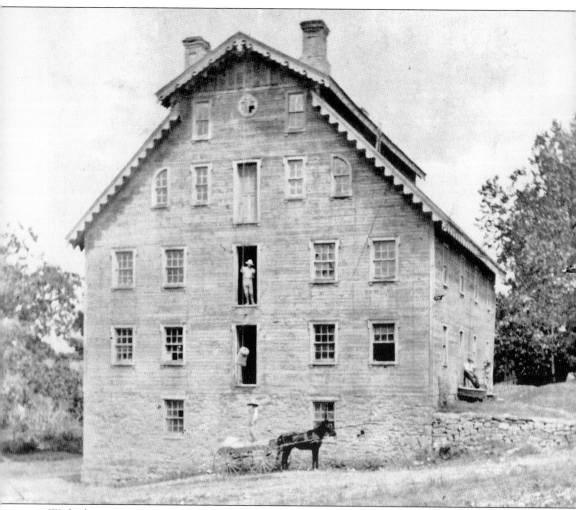

With the waterpower provided by its many creeks and rivers, milling was a major industry in Carroll County from the beginning. An industrial survey from 1852 found 147 gristmills, 245 flour mills, 25 paper mills, 33 cotton mills, 43 woolen mills, and 188 sawmills across the county. Seen here is Trevanion, located between Uniontown and Taneytown. The first mill on the site, a brick structure built by David Kephart in 1817, was known as "Brick Mills." In 1855, W. W. Dallas purchased the mill and 358 acres of land, including a house. Over the next two years, Dallas transformed the house into an Italianate mansion and rebuilt the mill to complement his home. He then renamed the property "Trevanion," an old family name. Dallas sold the mill in 1865 and moved to Philadelphia. While the house is still standing, the mill was torn down in the 20th century. (HSCC.)

Around 1730, several German families moved south from Pennsylvania and settled in what is now Silver Run. Situated on the Littlestown Pike, just four miles from the Mason-Dixon Line, the town takes its name from the nearby creek. As the area's farms prospered, merchants and tradesmen set up shop along the pike. In 1908, A. W. Feeser opened a cannery to process tomatoes. By 1925, the firm had 3 factories and 15 farms across the county and produced over 300,000 cases annually. The cannery provided employment for many of the town's residents until it ceased operations in the late 1960s. The image below, taken November 7, 1911, shows the lodge hall of the Ancient Order Knights of the Mystic Chain on election day, when it served as a polling place. It still stands, though it has been greatly altered. (HSCC.)

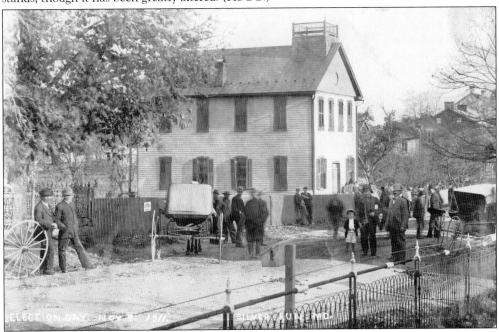

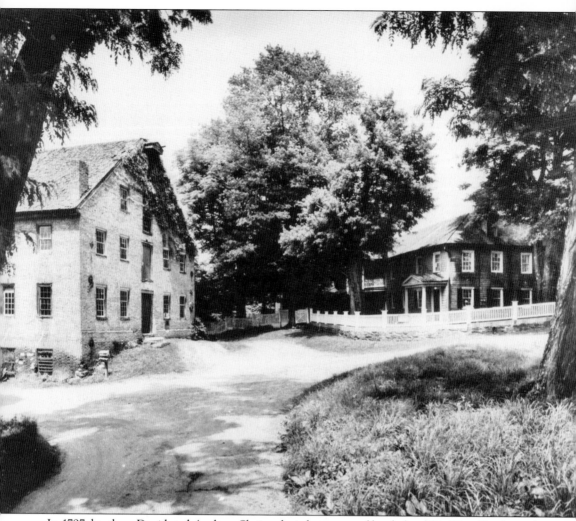

In 1797, brothers David and Andrew Shriver bought a tract of land along Big Pipe Creek north of Westminster along the Littlestown Pike. Andrew, a store owner in Littlestown, and David, a civil engineer, saw great potential in the creek's strong flow of water. The brothers constructed a gristmill and a sawmill soon to be called Union Mills. Most mills in Carroll County served the local residents, but Union Mills was a large commercial operation. Much of the mill's output was packed in barrels made on the site and then shipped through Baltimore to Europe. While the mill was under construction, a house was built for the brothers—a six-room double house with a connecting hall and front porch. As the family grew over the generations, the house was gradually expanded to 23 rooms. The complex became the center of the community with the house serving at times as a stagecoach stop and post office. The mill closed in 1942 but reopened as a restored, working historic site in 1983. (HSCC.)

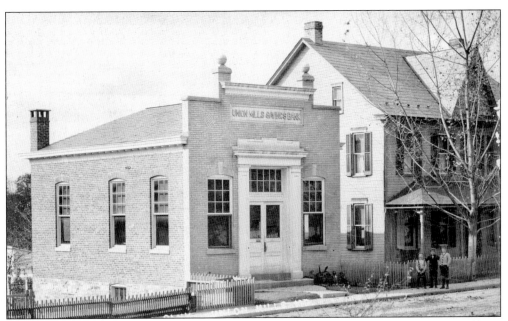

A small but thriving community grew up along the Littlestown Pike around Union Mills. A cluster of homes, schools, and stores lined the road. The Union Mills Savings Bank opened in August 1899 with an office in the home of bank treasurer C. E. Bankert. The building seen here opened in 1908 with an addition constructed in 1930. Though the building still stands, it is no longer a bank. (HSCC.)

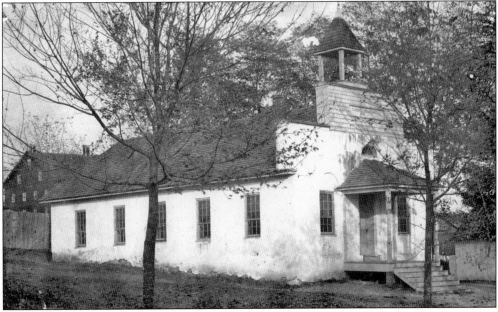

Carroll Academy was founded in 1838 near Union Mills. A board of trustees oversaw the school, hiring the teachers, setting fees, and seeing to the maintenance of the building and grounds. In 1868, the board turned the school over to the county. The building was enlarged in 1879. In 1921, the opening of Charles Carroll School nearby forced the closing of the academy building. (HSCC.)

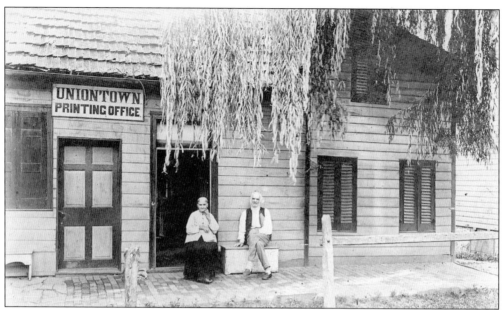

During the late 19th century, small presses operated in many Carroll County communities. Beginning in 1859, Jacob H. Christ published a newspaper from the Uniontown Printing Office, located in his father's house. The paper was known as the *Enterprise* from 1859 to 1860 and as the *Weekly Press* from 1860 to 1863. The press also did job printing for local residents. The couple in this *c.* 1875 photograph is probably Christ's parents. The Christ house was demolished in the 1920s. (HSCC.)

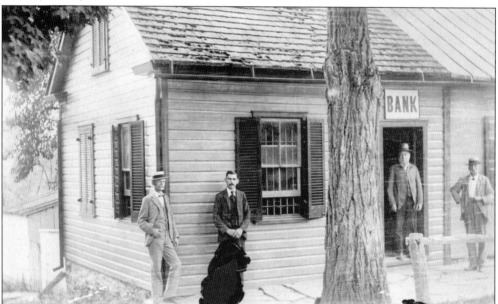

The Carroll County Savings Bank was established in Uniontown in 1871 and moved into the building seen here in 1883. From left to right in this photograph are Dr. Jacob J. Weaver Jr., Jesse P. Garner, David Myers, and Edwin Gilbert. The bank moved to a new building on Uniontown Road in 1907, and the frame building was later demolished for construction of the Uniontown school. (HSCC.)

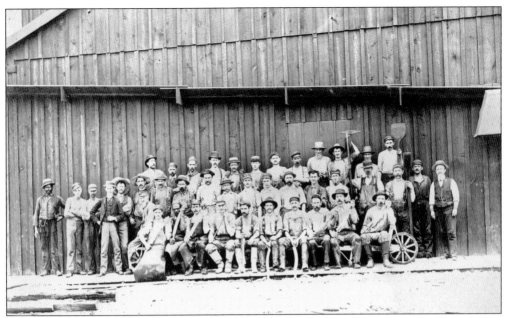

Tannery, one mile from Westminster, centered around a single industry—tanning leather. The community included the factory complex, a post office, general store, and workers' homes. The plant was known by several names over the years, including A. P. Baer and Company and, at the time this photograph was taken, Schlosser Tannery. The plant closed in 1919. Attempts to open a distillery there in the 1930s were unsuccessful. (HSCC.)

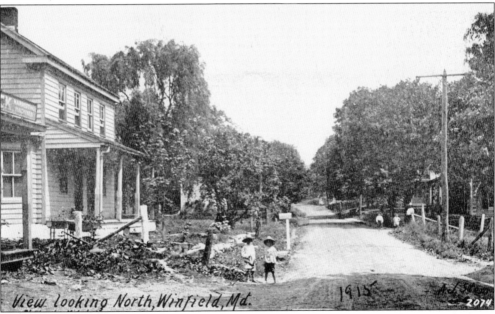

Winfield was established in 1852 when Aquilla Pickett built a house at the intersection of Liberty Road and Sam's Creek Road in southern Carroll County. The town takes its name from Gen. Winfield Scott, a hero of the Mexican War. By the time of this c. 1915 postcard, it included two stores, a shoemaker, a carriage and harness shop, and a community hall belonging to the Patriotic Order Sons of America. (HSCC.)

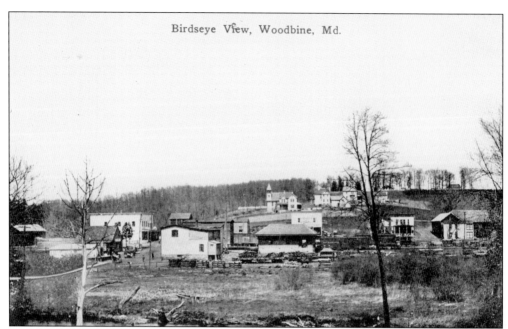

Birdseye View, Woodbine, Md.

At the southern border of Carroll County sits Woodbine (above), nestled along the Patapsco River and the B&O Railroad. The railroad allowed goods to be shipped quickly and inexpensively, and the river provided waterpower to run a small but thriving industrial center. Two canning factories processed the crops from local farms. There was a paper mill as early as 1862, and the industry survived for another century. By the time the photograph below was taken around 1900, the Woodbine Paper Mills had grown into a large operation. The community—named for a honeysuckle vine that was common in the area—supported a post office, three grocery stores, the Woodbine Hotel, and the Woodbine National Bank. (HSCC.)

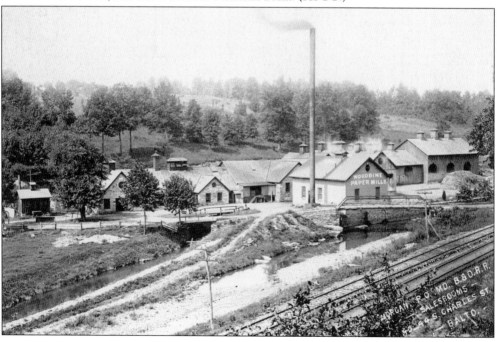

Ten

CELEBRATING CARROLL COUNTY

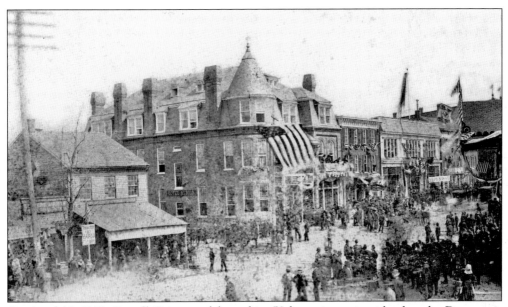

On April 11, 1887, Carroll County celebrated its 50th anniversary with what the *Democratic Advocate* called the "Greatest Celebration in Western Maryland." Twenty thousand visitors poured into Westminster, many arriving via special trains on the Western Maryland Railroad. The gala began with a parade that followed a four-mile route through the city. Led by hundreds of bicycles decorated with ribbons and flags, the parade included 14 bands, several fire departments, displays by county businesses, and even an "Old Citizens Division." Among the "Old Citizens" was 76-year-old Col. John Longwell, who was instrumental in the county's founding. This photograph shows the parade on Main Street, passing the intersection with Liberty Street. Later that day, Judge William P. Maulsby presented a grand oration, and Harry J. Shellman read a poem written for the occasion. Finally all the bands consolidated and performed as one to close the festivities. (HSCC.)

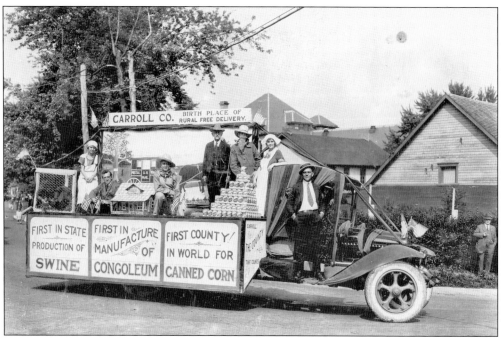

The opening of a new bridge across the Severn River at Annapolis in 1923 provided communities around the state an opportunity to join in the festivities. Carroll County's float for the parade touted the county's role in creating the rural free delivery system, its agricultural heritage, and modern industries such as Congoleum, which purchased the Baltimore Roofing plant in 1921 to manufacture the felt used in the company's signature synthetic flooring. (HSCC.)

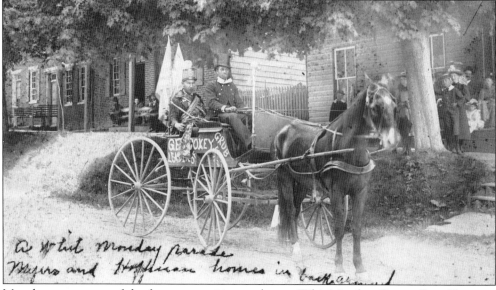

Manchester was one of the few communities to observe Whit-Monday. Originally a Christian celebration held on the day after Pentecost, by the 19th century it had become a day of community celebration. The holiday was especially popular in the United Kingdom and was likely brought to Manchester by the town's early settlers. Parades (seen here c. 1900), band concerts, and picnics marked the occasion. The tradition continued until the early 1920s. (HSCC.)

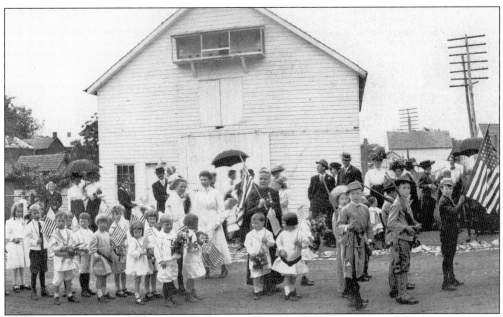

Mary Shellman, seen holding a flag at the center of this *c.* 1915 photograph (above), initiated Westminster's observance of Memorial Day on May 30, 1868, when she organized local schoolchildren to place flowers on the graves of Westminster's Civil War dead. The parade began at the west end of town and proceeded east on Main Street to Westminster Cemetery's entrance on Church Street. The *c.* 1900 photograph below was taken from inside the cemetery and shows the parade making its way up Church Street to the cemetery's gates. Miss Shellman ran the annual event until 1880, when Westminster's Burns Post No. 13, Grand Army of the Republic, took over the task. Westminster has continuously observed Memorial Day longer than any other city in the country, and the event still includes children laying wreaths at the cemetery to honor the city's servicemen. (HSCC.)

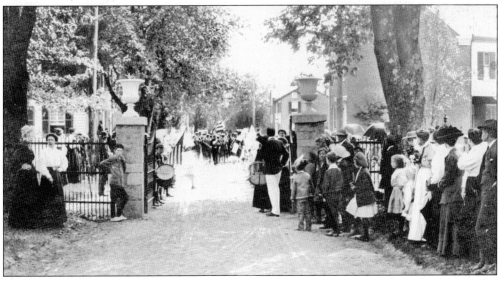

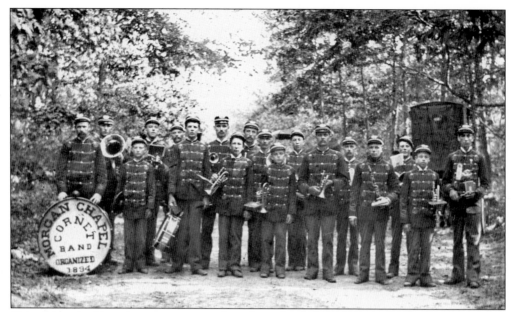

Community bands were once commonplace throughout Carroll County. The bands provided music for social events such as picnics, parades, and patriotic observances, and often traveled to nearby communities to perform. The county's incorporation records provide the names of 40 local bands organized between 1857 and 1952. Morgan Chapel, a crossroad centered around Morgan's Chapel United Methodist Church, was home to a coronet band that was organized in 1894. (HSCC.)

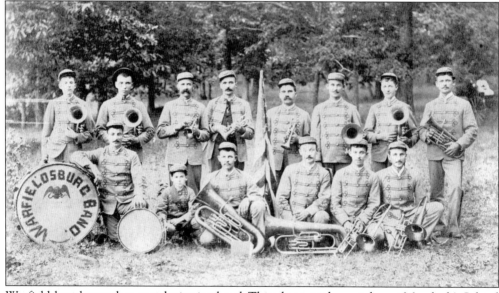

Warfieldsburg boasted an award-winning band. This photograph was taken at Morelock's School in 1890, shortly after the band won a competition in Waynesboro. Pictured here from left to right are (first row) William Foutz, Edward Summers, Howard Bower, Vernon Barnes, John Buckingham, and John Foutz; (second row) Harry Summers, Clayton Biggs, John W. Arbaugh, Prof. Bailey Morelock, Prof. Isaac Buckingham, Clarence Lantz, Noah Arbaugh, and Charles Lantz. (HSCC.)

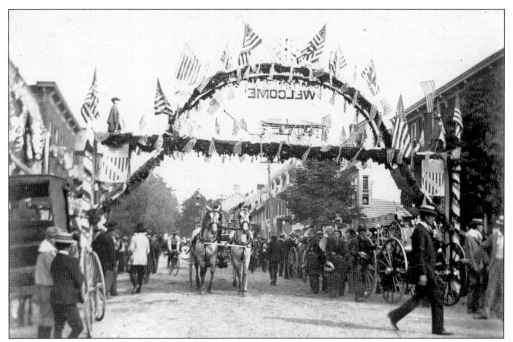

Staging the State Firemen's Convention was an honor for the host city. Westminster hosted the convention in June 1899. The opening parade of fire companies, fire apparatus, bands, and military units marched east on Main Street past the firehouse. There the large arch seen here—decorated with red, white, and blue lights and a miniature ladder truck—had been constructed across the street. (HSCC.)

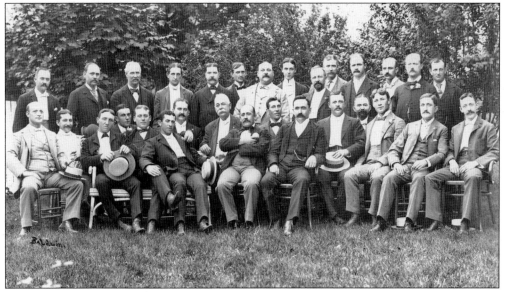

The "Baseball Invasion of Westminster" occurred on Sunday, June 21, 1896, when the Baltimore Orioles arrived at the home of Prof. James Diffenbaugh. Manager Ned Hanlon and his players, including Willie Keeler, Joe Kelley, and Wilbert Robinson, arrived on the morning train. Photographer J. W. Baldwin captured this image before the group left on the evening fast mail train. The Orioles captured their third consecutive National League pennant that year. (HSCC.)

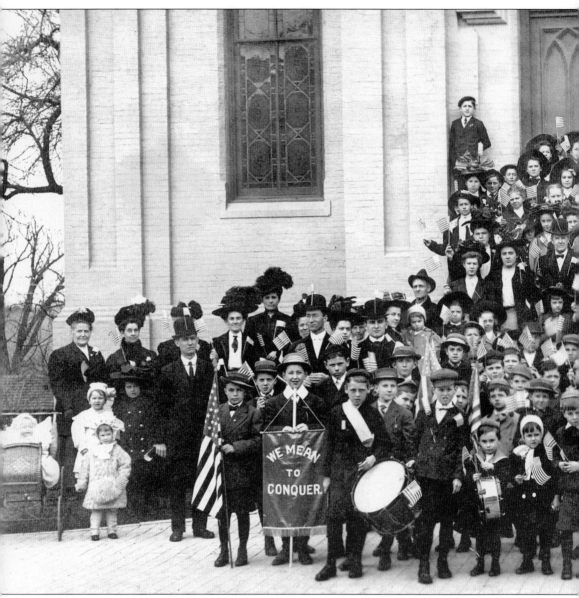

Temperance had been a periodic reform issue in Carroll County since the 1840s, when a national movement formed to promote abstinence from alcoholic beverages. The movement gained momentum in Maryland throughout the 19th century and led to the passage of the Local Option Law, which allowed each county to decide to become "dry" or remain "wet." At a time when only men could vote, women and children were at the forefront of the Temperance movement.

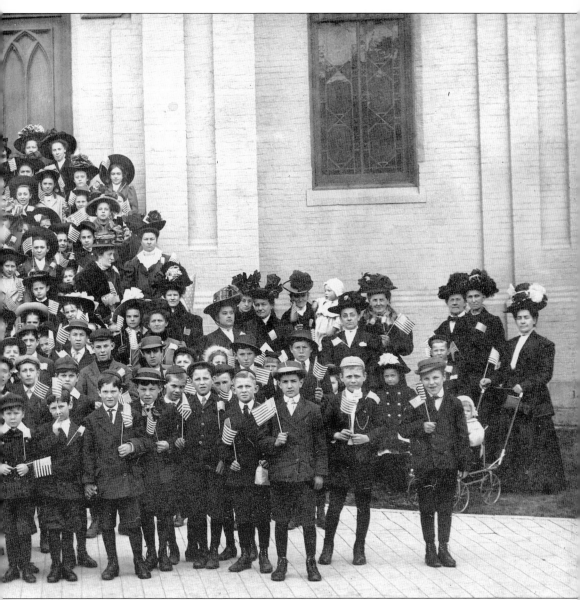

Temperance rallies, such as this one led by Mary Shellman (far left), proved an effective method of drawing attention to the cause. Carroll County Drys won in 1914, and the sale of alcohol in the county was banned five years before nationwide Prohibition. This photograph was taken in front of the Methodist Protestant Church on Westminster's Main Street. The building became the Davis Library in 1951. (HSCC.)

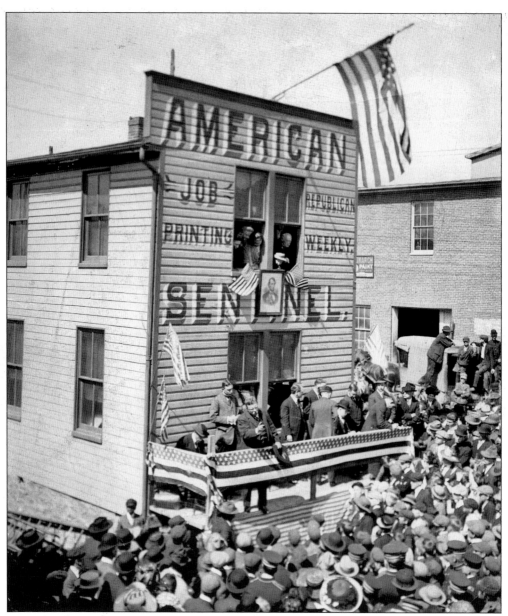

Pres. Theodore Roosevelt had left office in 1908, turning over leadership of the Republican party to William Howard Taft. By 1912, Roosevelt was back, challenging Taft in the primaries for the Republican nomination. In May, he embarked on a campaign trip that brought him to Maryland. On May 4, Roosevelt arrived at his first stop in Carroll County—New Windsor—where he made a whistlestop speech. Then it was on to Westminster for a speech in front of the *American Sentinel* newspaper office. The paper reported that about 1,500 people paid "strictest attention to every word uttered by the speaker" before Roosevelt reboarded his train and continued on his way to Baltimore. Roosevelt would loose the Republican nomination and form his own party, the Progressive (Bull Moose) party, for the general election. (HSCC.)

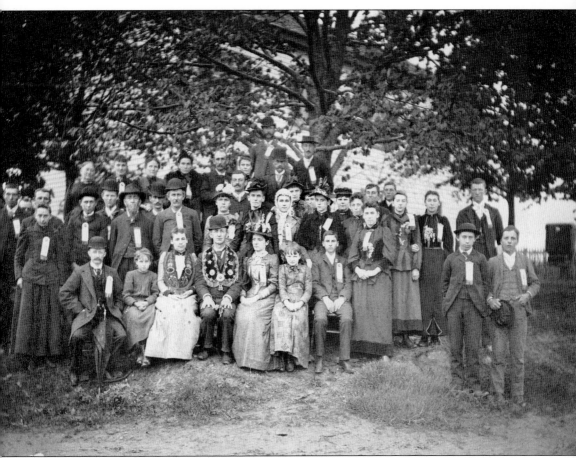

The International Order of Good Templars, Freedom District, posed in front of the old Masonic Hall, opposite the New Freedom Church, 1885–1890. The I.O.G.T., one of several temperance organizations that appeared in the mid-19th century, traces its roots to a lodge established in Utica, New York, in 1852. Soon lodges appeared across the country. Included in this photograph are Pinkney Baker, Emma Bennett, David Rice, Ida Shipley, Vernon Ridgely, Louise Ridgely, Jim Carter, Bernard Brandenburg, Mr. ? Norris, Frank Lewis, Lucy Davis, Martha Gilliss, Ada Carter, Stella Shipley, ? Bennett, ? Ruby, Ollie DeVerese, Will Brandenburg, Mandy Buckingham, Susie Shipley, Tom Bennett, Lizzie Baker, Mr. ? Remells, Lum Conaway, Carrie Penn, Luella Conaway, Leana Davis, ? Bennett, Rob Carter, ? Selby, and ? Bennett. (HSCC.)

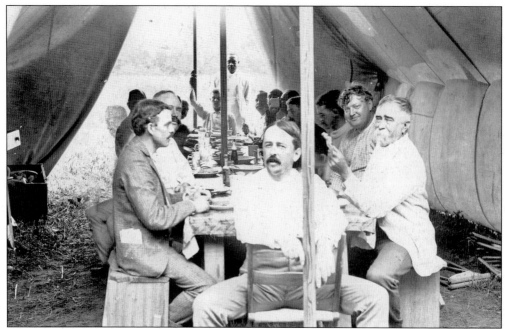

Among the earliest local sportsmen's clubs was the Forest and Stream Club of Carroll County, founded in 1874. The members camped and fished along the Monocacy River, although they hired a cook to accompany them. This *c.* 1890 photograph shows the group at one of their campsites. In front from left to right are Dr. Joseph Hering, Fred Miller, and Dr. George Bachman. (HSCC.)

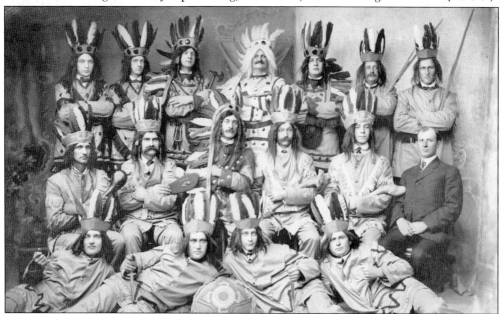

This 1910 photograph shows the members of the Westminster Lodge, Improved Order of Red Men. The lodge used Native American regalia in honor of the Sons of Liberty, who threw tea into Boston harbor in 1773 and based its organizational structure on the Six Nations of the Iroquois. By the late 19th century, the group had over 150,000 members nationwide. Carroll County also had lodges in Manchester, Patapsco, and Uniontown. (HSCC.)

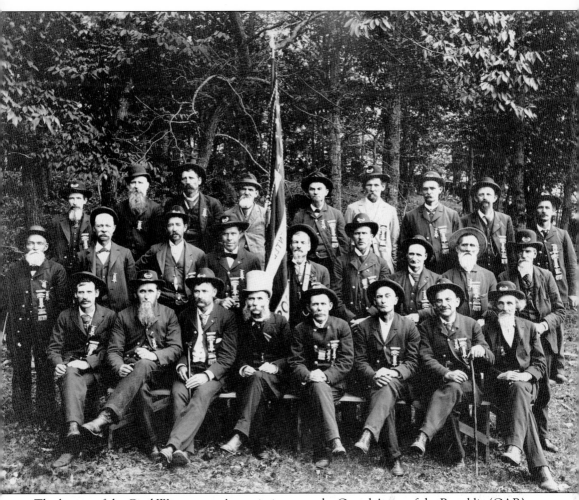

The largest of the Civil War veterans' associations was the Grand Army of the Republic (GAR), an organization for Union veterans. By 1890, GAR membership included over 409,000 veterans, organized in "posts" in their local communities. The members of Pickett Post No. 17, Winfield (seen in this undated photograph), were mostly veterans of Company E, 4th Maryland Infantry. The post was named in honor of two local boys, Corporals Noah and Celious A. Pickett, who died of wounds received during the Wilderness Campaign. Pictured from left to right are (first row) Milton Belinson, Daniel Hartsock, Gasaway Rawlings, William Miller, James Easton, David McQuay, Ruben Conoway, and Samuel Streaker; (second row) George Goodwin, Lewis Prough, Bill Groves, Mahon Bowers, John R. Fawcett, Francis L. Criswell, Jess Porter, Edward Streaker, and ? Streaker; (third row) Charles Porter, unidentified, Vince Smith, Rev. J. B. Hall, Samuel Kennell, ? Miller, Tom McQuay, Augustus Zile, and Andrew Jackson Fritz. Also in Carroll County were Thaddeus Stevens Post No. 40 in New Windsor and Burns Post No. 13 in Westminster. (HSCC.)

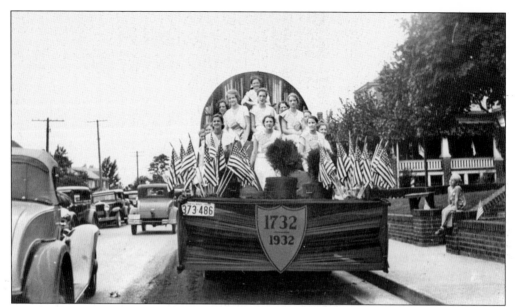

In 1932, the United States commemorated the 200th anniversary of George Washington's birth with a yearlong celebration. The highlight in Carroll County came on July Fourth with a parade through the streets of Taneytown to the fairgrounds. The day closed with the playing of Sousa's *Washington Post March* by a massed band composed of all the bands from the parade. A crowd estimated at 25,000 attended the festivities. (HSCC.)

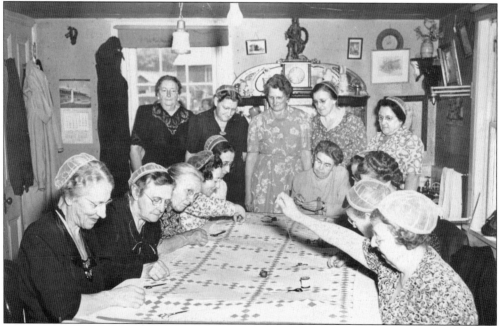

Quilting parties were popular social opportunities for women, and the tradition continues in Carroll County. Women often gathered to make quilts to be sold or raffled to benefit their church, or quilts to be given as gifts to neighbors and church members. The Aid Society of Meadow Branch Church of the Brethren, seen in this 1941 photograph, met every week for quilting, lunch, and fellowship and over the years completed over 300 quilts. (HSCC.)

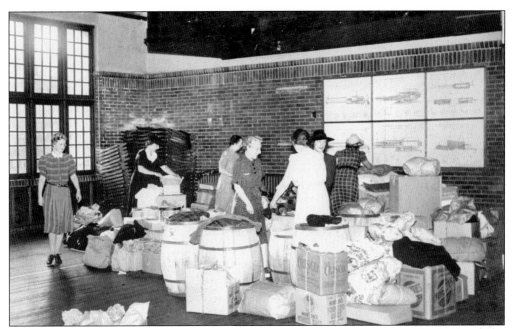

Early in World War II, as England withstood Germany's aerial attacks, America began sending money and supplies to the British. In 1939, a New York socialite organized her friends to knit items for British sailors. The program expanded into "Bundles for Britain," which collected knitted items, used clothing, and supplies for shipment overseas. In this October 1940 photograph, Carroll County women sort and pack donated items in the Westminster armory. (HSCC.)

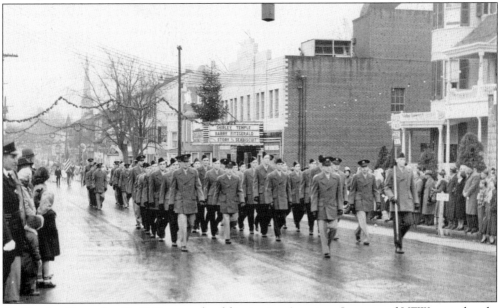

On Sunday, December 11, 1949, a parade of dignitaries, American Legion and VFW posts, bands, and the ROTC of Western Maryland College marched west on Westminster's Main Street to the World War II memorial at the "Forks" with Pennsylvania Avenue. Sen. Millard E. Tydings gave the keynote address at the ceremony dedicating the monument in tribute to Westminster's soldiers "of all wars for the courage and valor displayed." (HSCC.)

Carroll County marked its centennial with a gala celebration from May 30 through June 3, 1937. Monday, May 31, was a busy day. That morning, the Industrial Exhibition of Carroll County Manufactured Products opened in the armory. Businesses from across the county created large displays, such as the one from Congoleum-Nairn, Inc. (above), which explained the manufacturing process and was floored with Congoleum. The day included a horse show and a parade with floats, bands, and 40 fire companies. Wednesday, June 2, featured a competition for Carroll County bands. Each entry played a march and an overture for the judges. The Mount Airy Boy's Band (below) took home first prize and $30. (HSCC.)

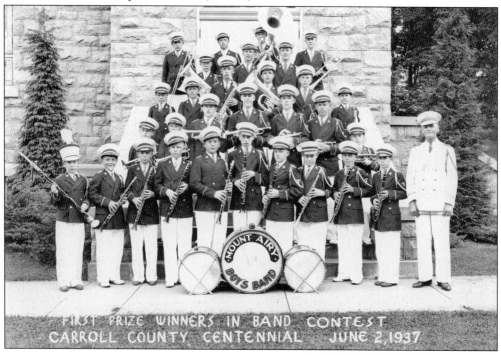

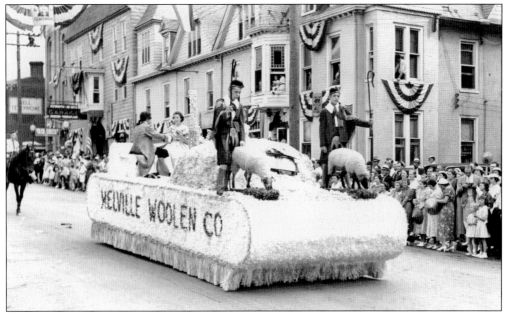

The centennial celebration continued on Wednesday night with the presentation of "The Carroll County Caravan, A Pageant of This Soil." The next day, June 3, festivities concluded with the Grand Parade. Thousands lined the streets of Westminster for the event. Companies from across the county—including the Melville Woolen Mill in Oakland (above) and Baumgardner's Bakery in Taneytown (below)—spent countless hours on their presentations in hopes of being named "Best Display of any business firm in Carroll County." Other prizes were awarded for Best Band, Best Drum Corps, Best Historical Float, Oldest and Most Historic Vehicle, and Best Appearance in Parade of any Carroll County District. Getting the whole city involved, prizes were also awarded to the best-decorated residence and business. (HSCC.)

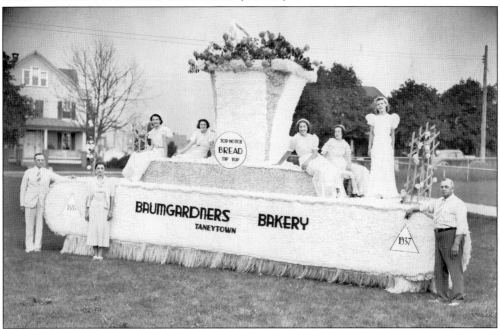

ACROSS AMERICA, PEOPLE ARE DISCOVERING SOMETHING WONDERFUL. *THEIR HERITAGE.*

Arcadia Publishing is the leading local history publisher in the United States. With more than 3,000 titles in print and hundreds of new titles released every year, Arcadia has extensive specialized experience chronicling the history of communities and celebrating America's hidden stories, bringing to life the people, places, and events from the past. To discover the history of other communities across the nation, please visit:

www.arcadiapublishing.com

Customized search tools allow you to find regional history books about the town where you grew up, the cities where your friends and family live, the town where your parents met, or even that retirement spot you've been dreaming about.